WALLPAPER
COLORWAYS

COLORING PATTERNS
INSPIRED BY VINTAGE WALL COVERINGS

Just like the hand-drawn designs for wallpaper books

created by dedicated artisans, each motif in this

volume is ready for multiple color possibilities.

Use the circles printed with the art to set your palette,

then experiment with different options that suit your

style—rich and dark, light and airy, bright and bold.

Only your imagination sets the limit

on what you can do with color.

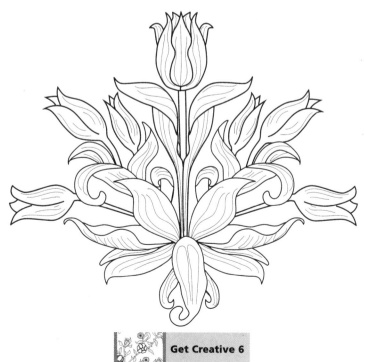

Get Creative 6

An imprint of Mixed Media Resources New York

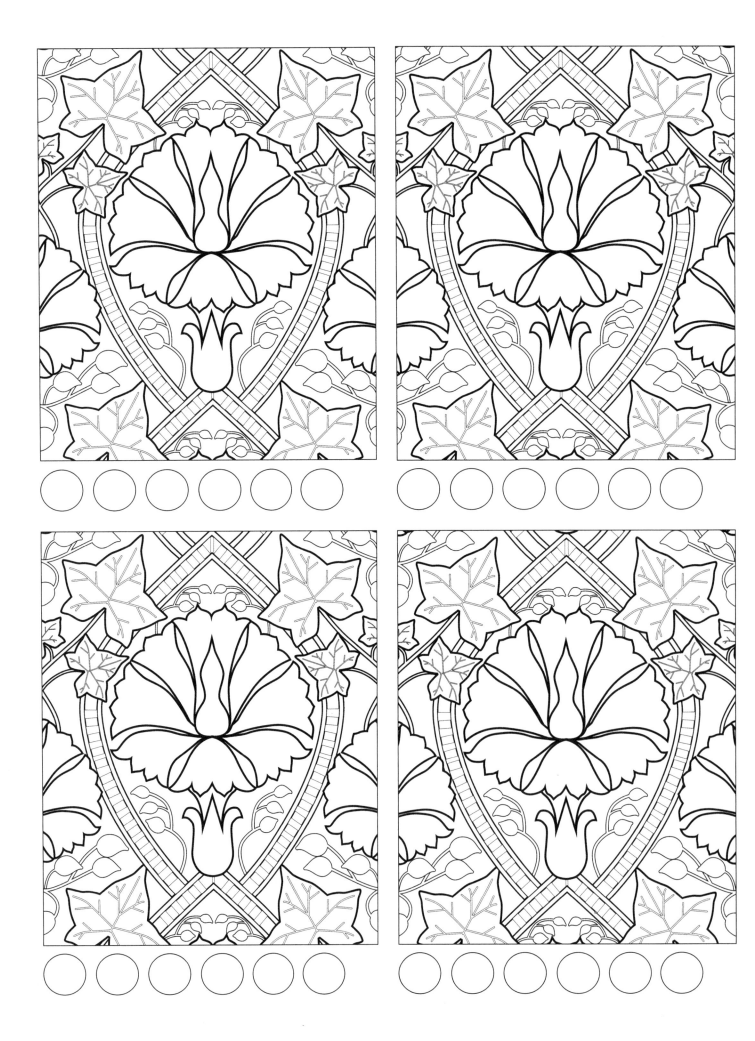

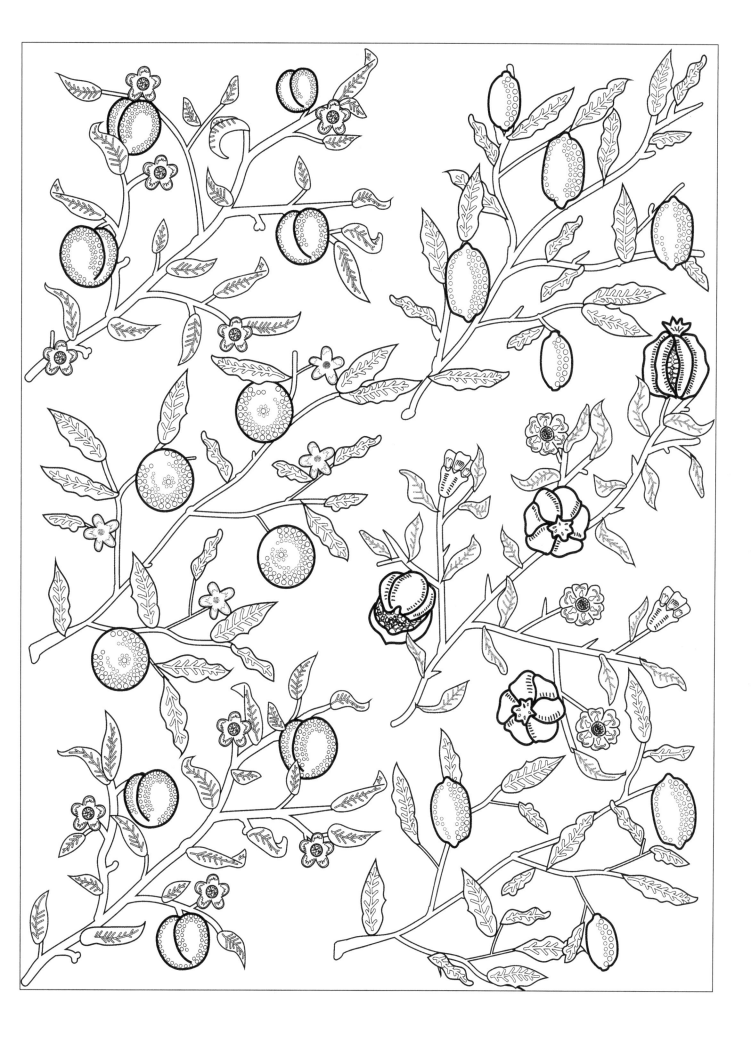

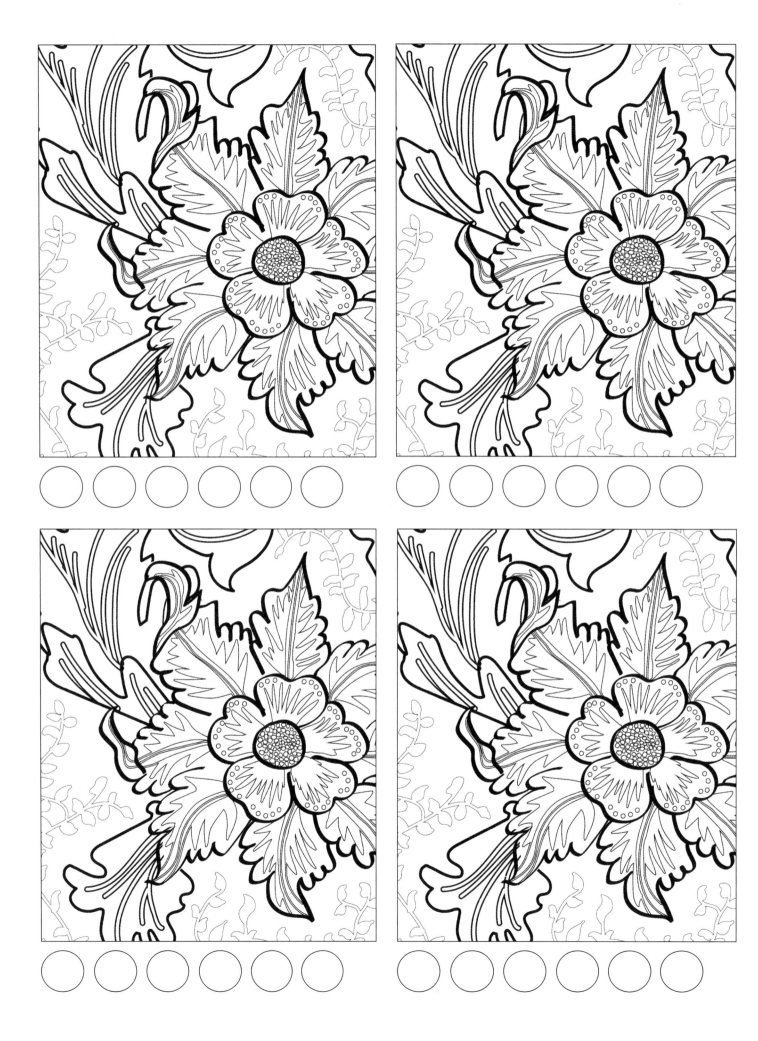

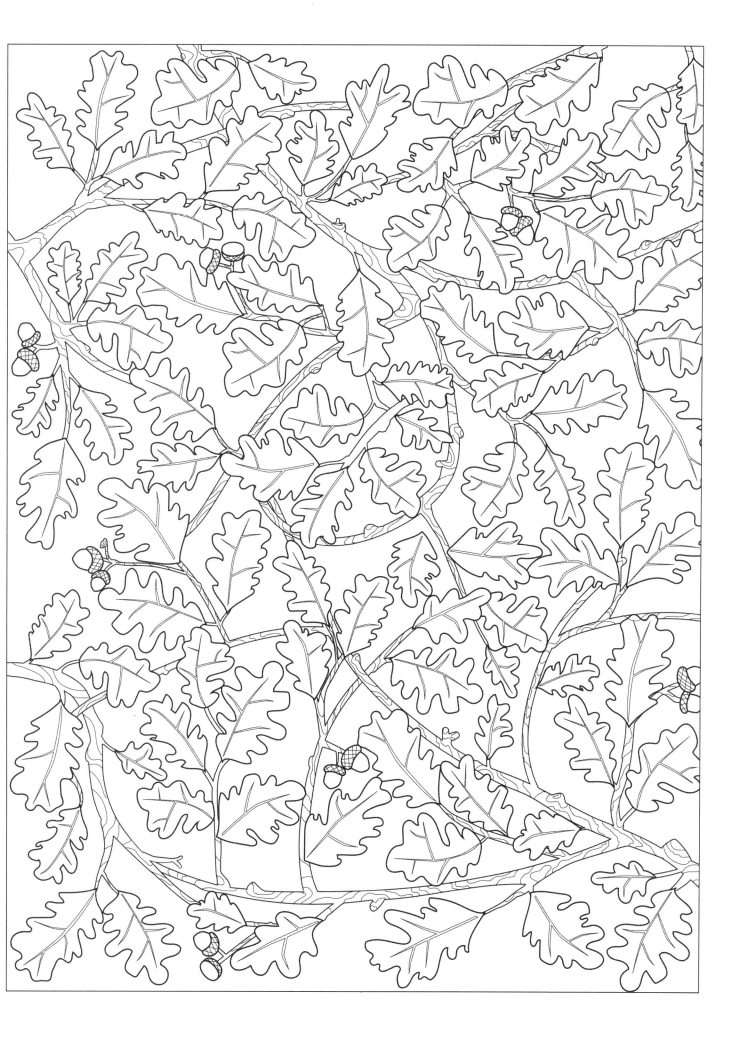

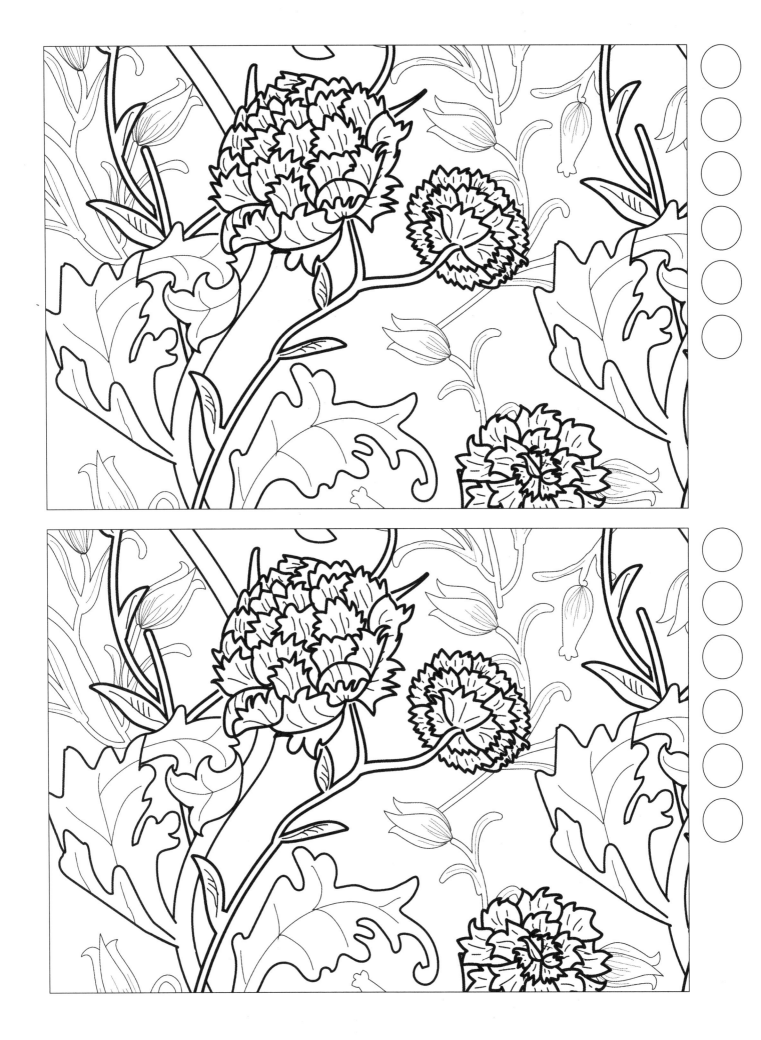

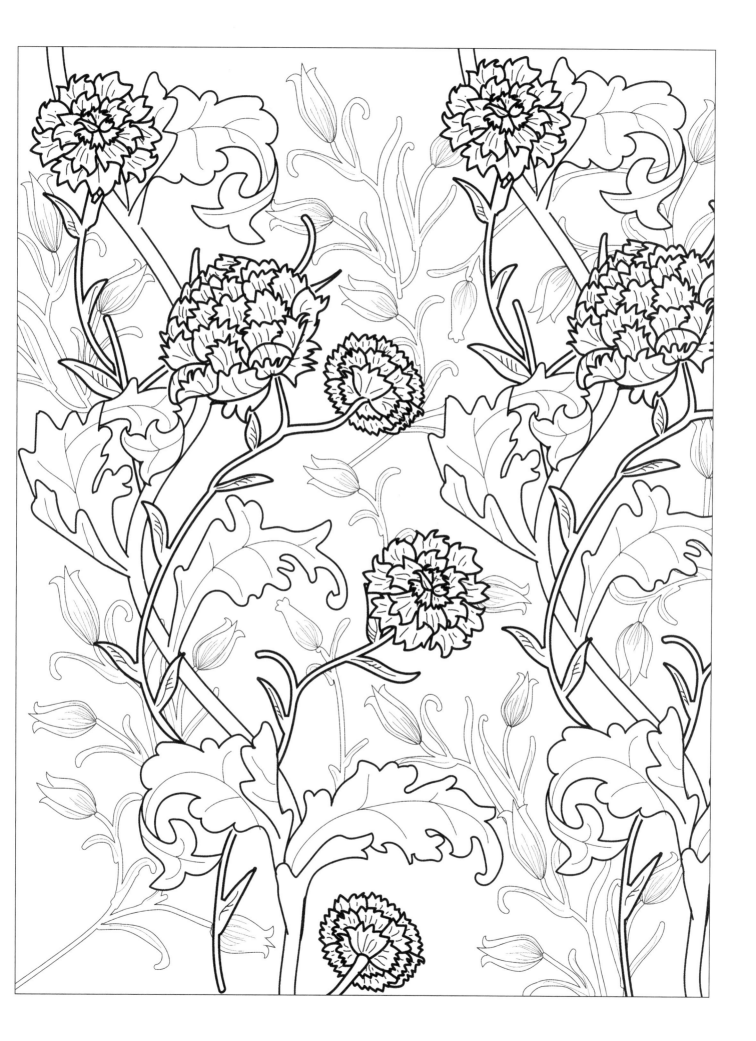

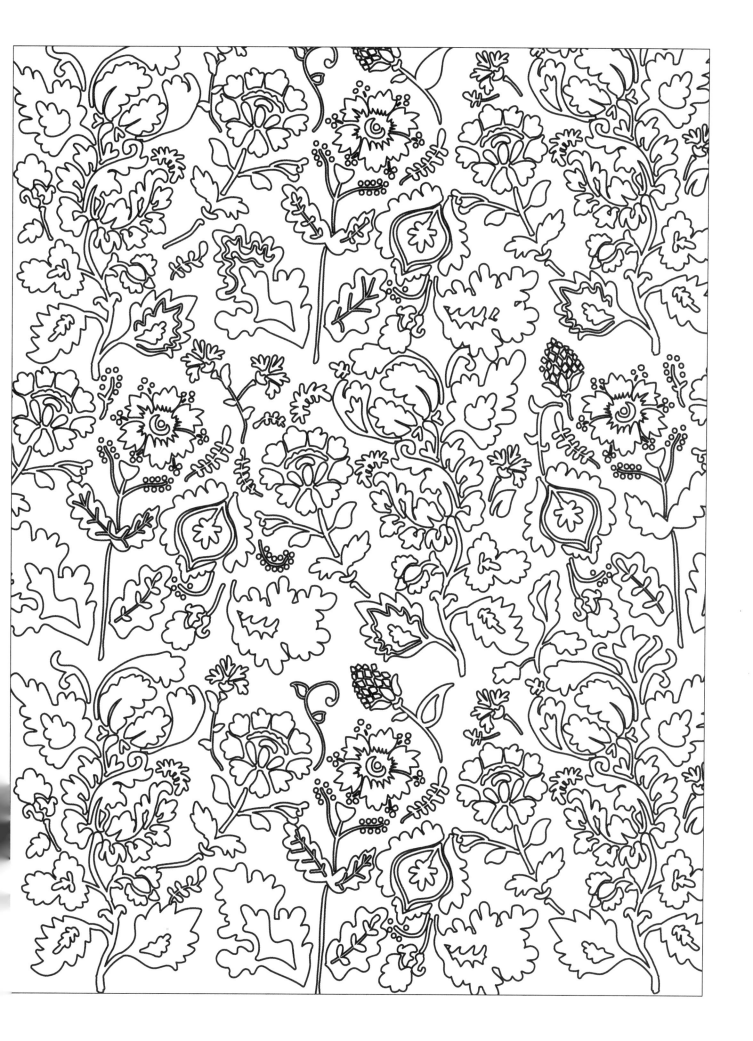

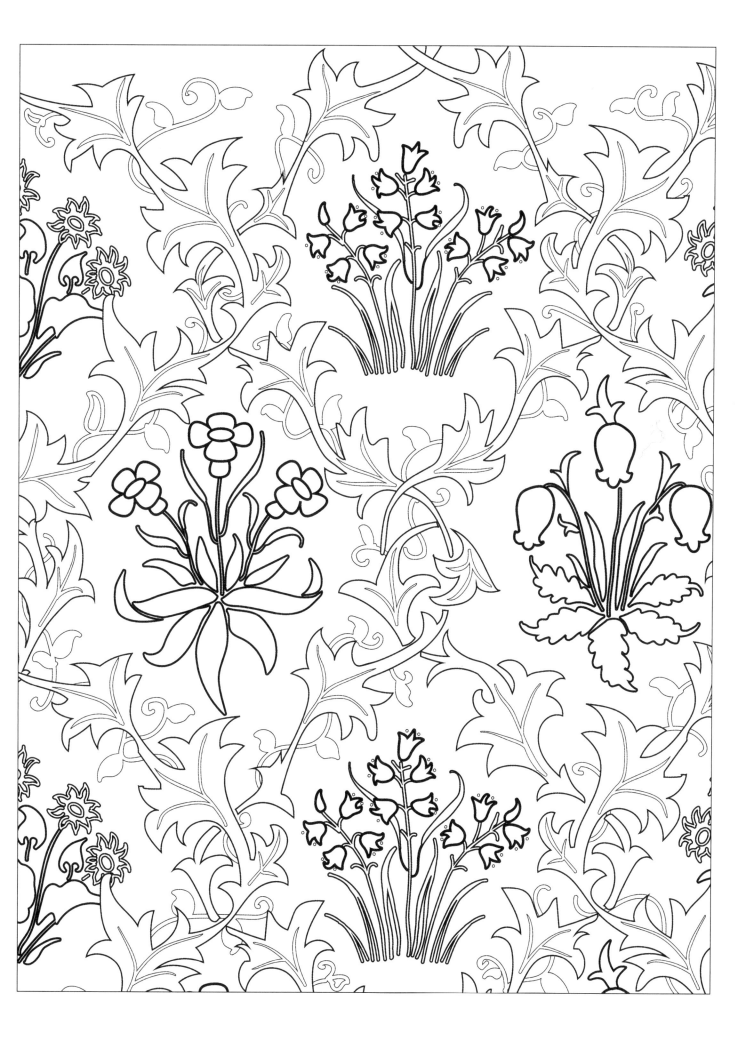

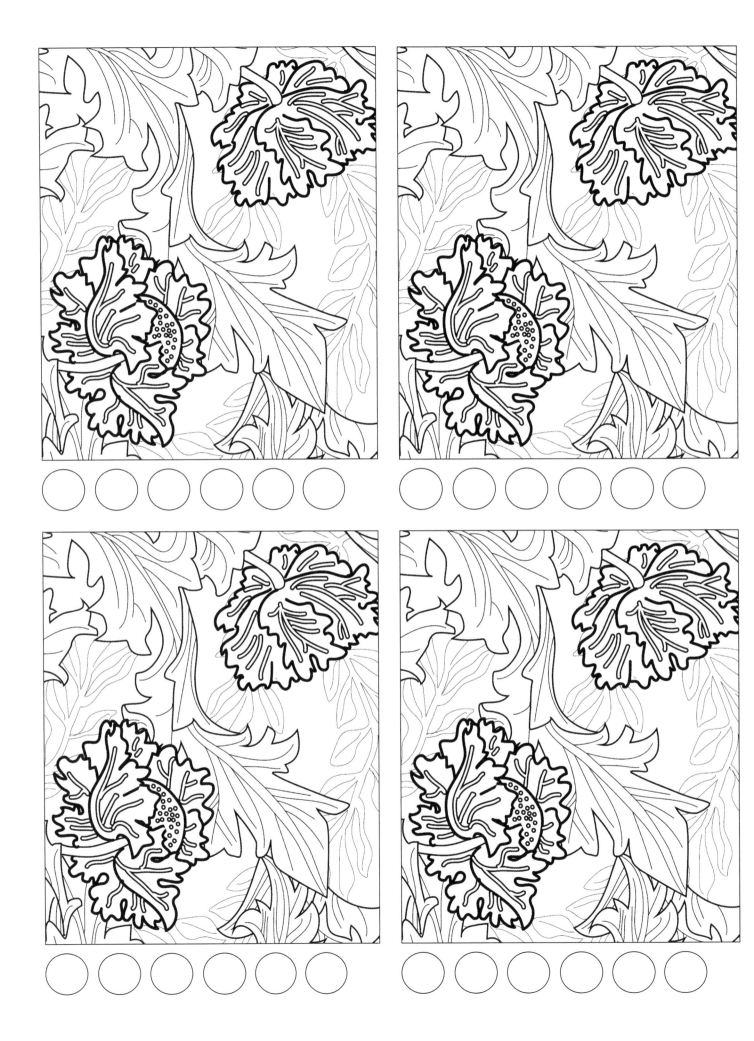

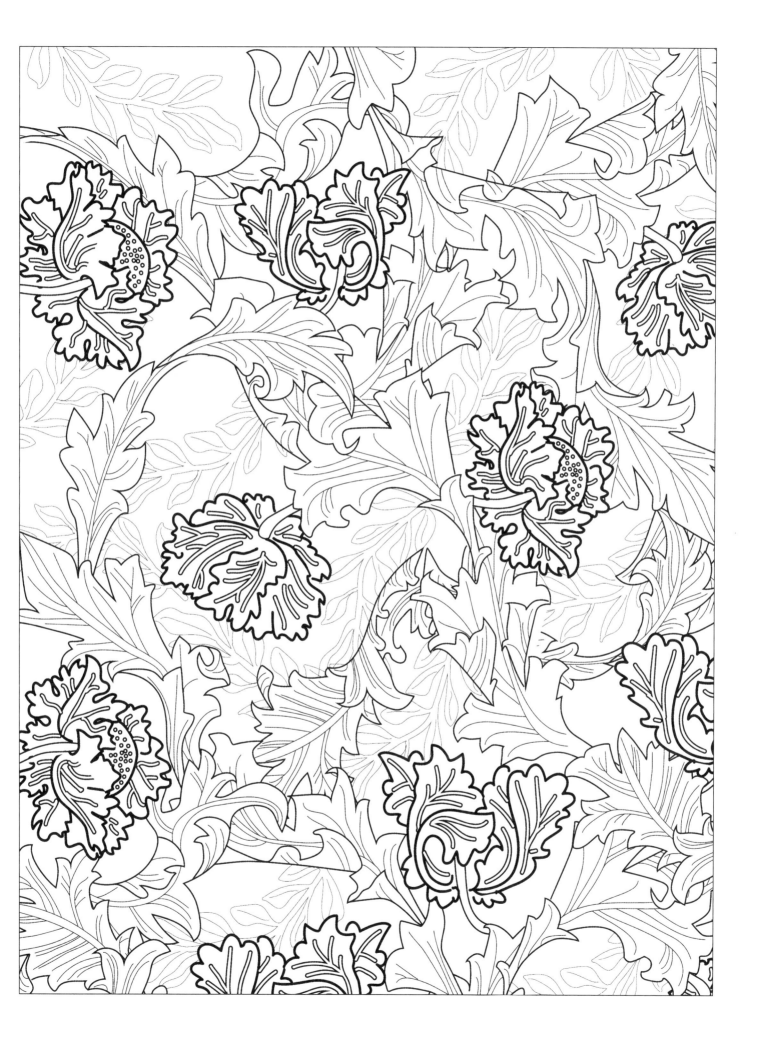

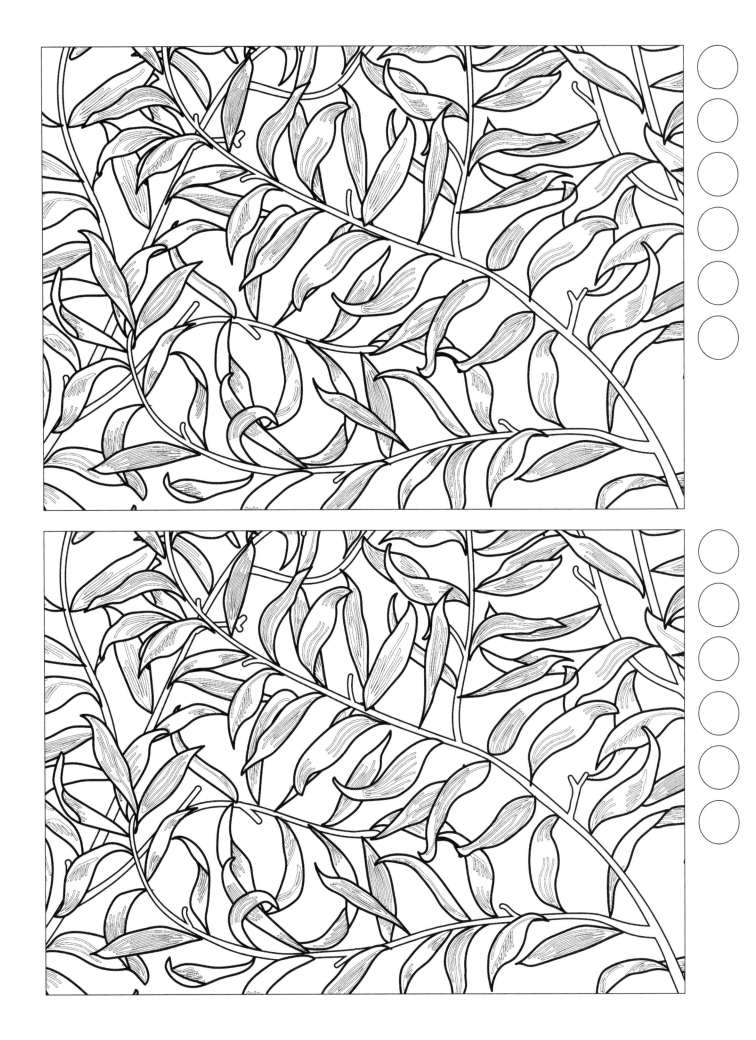

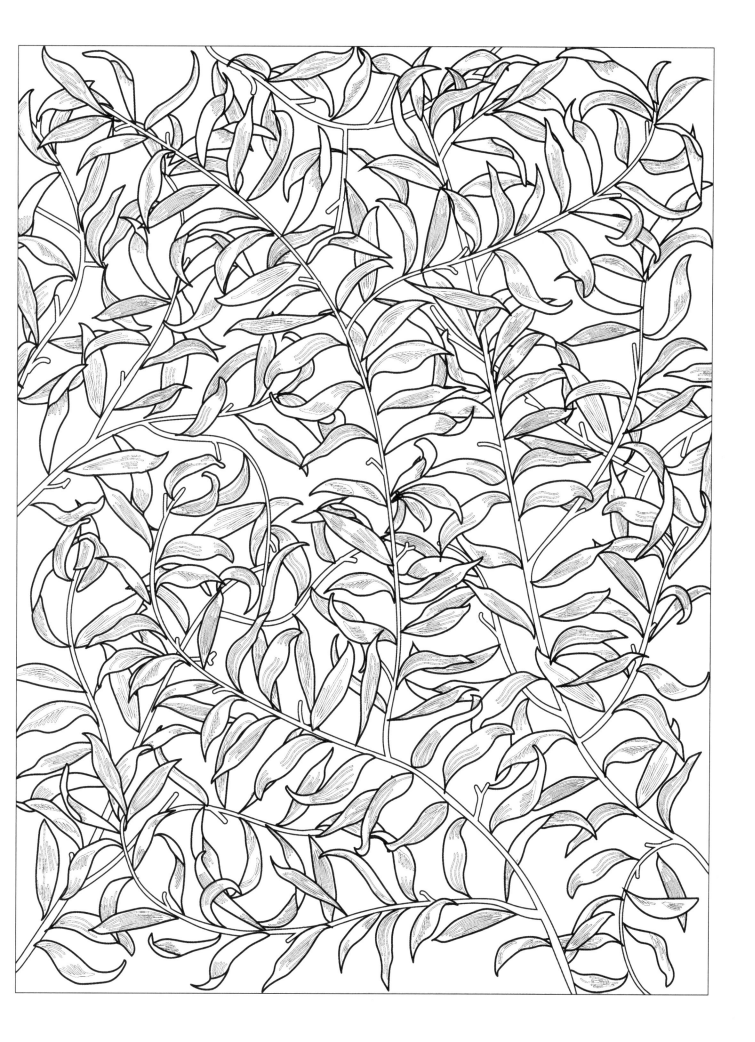

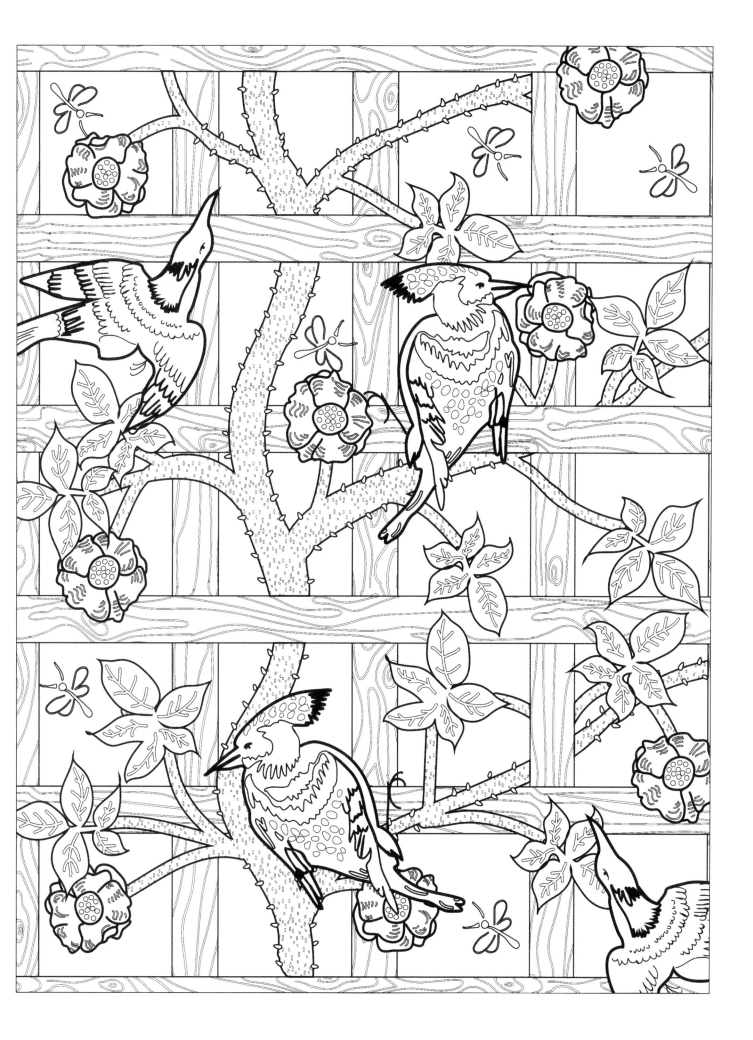

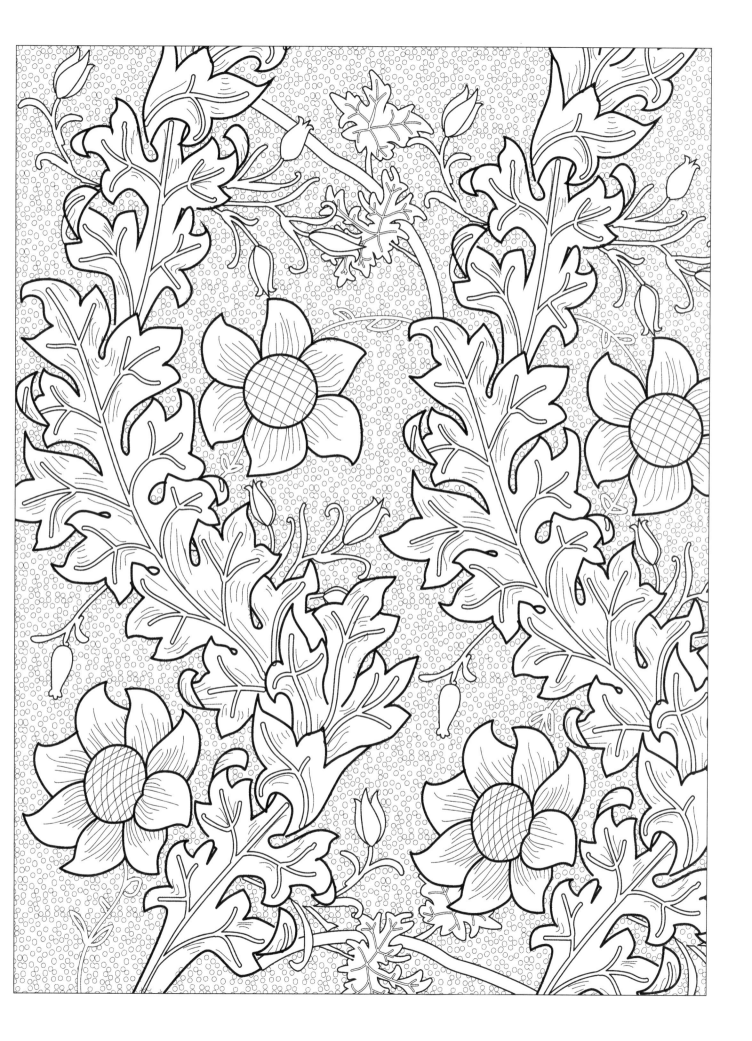

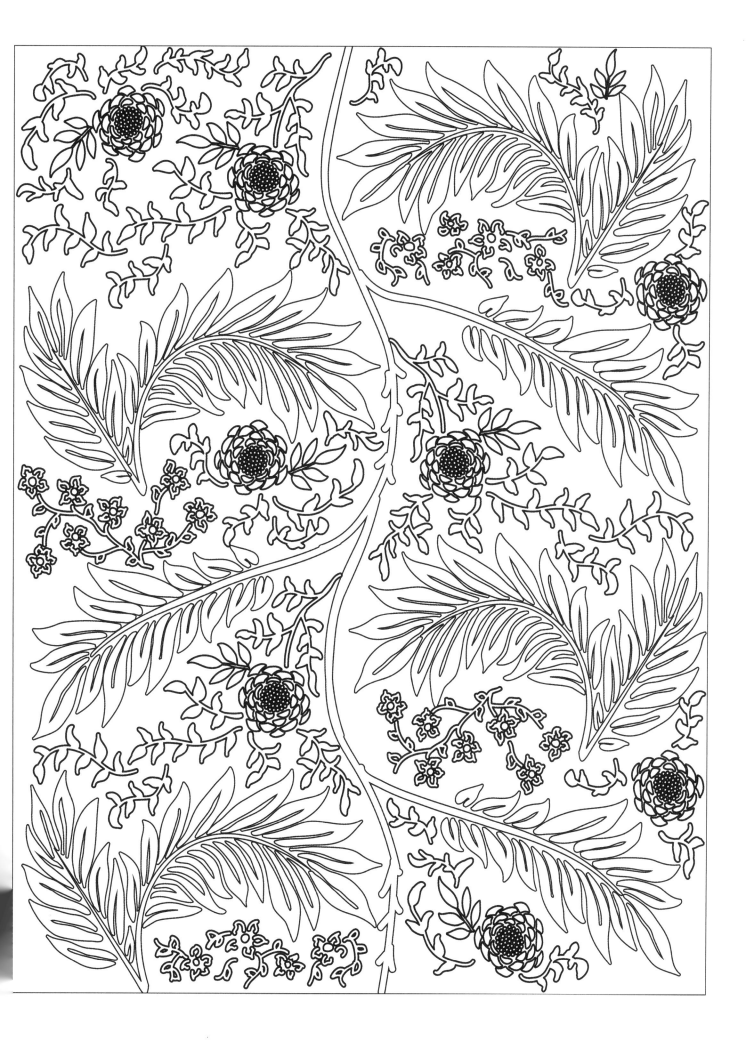

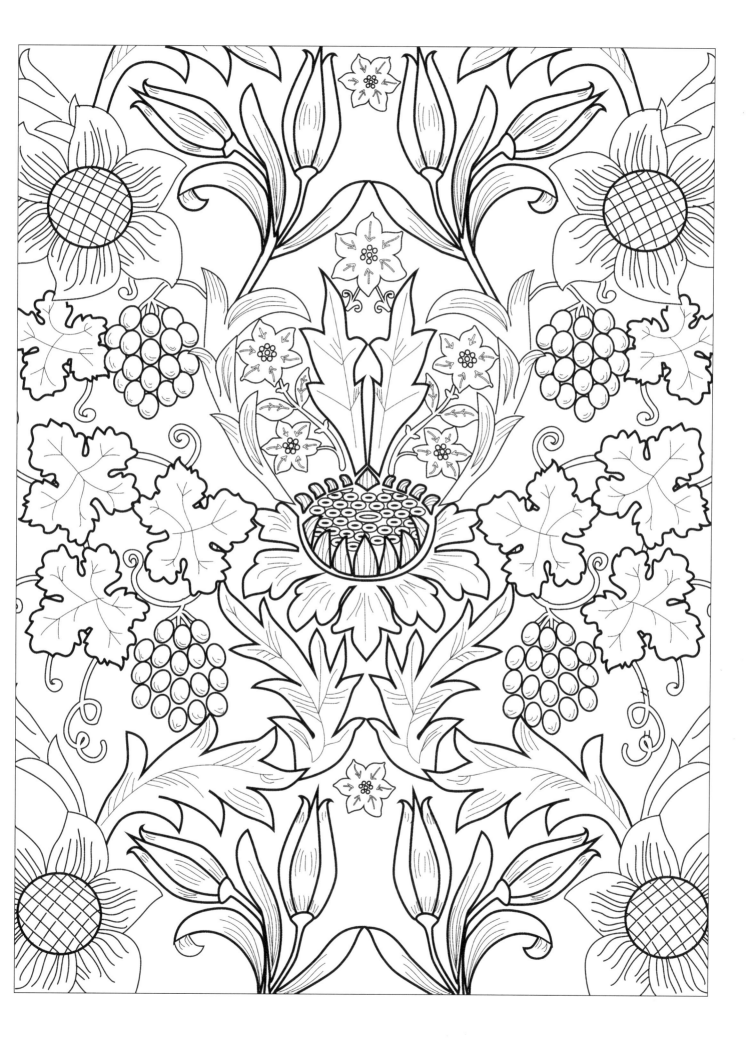

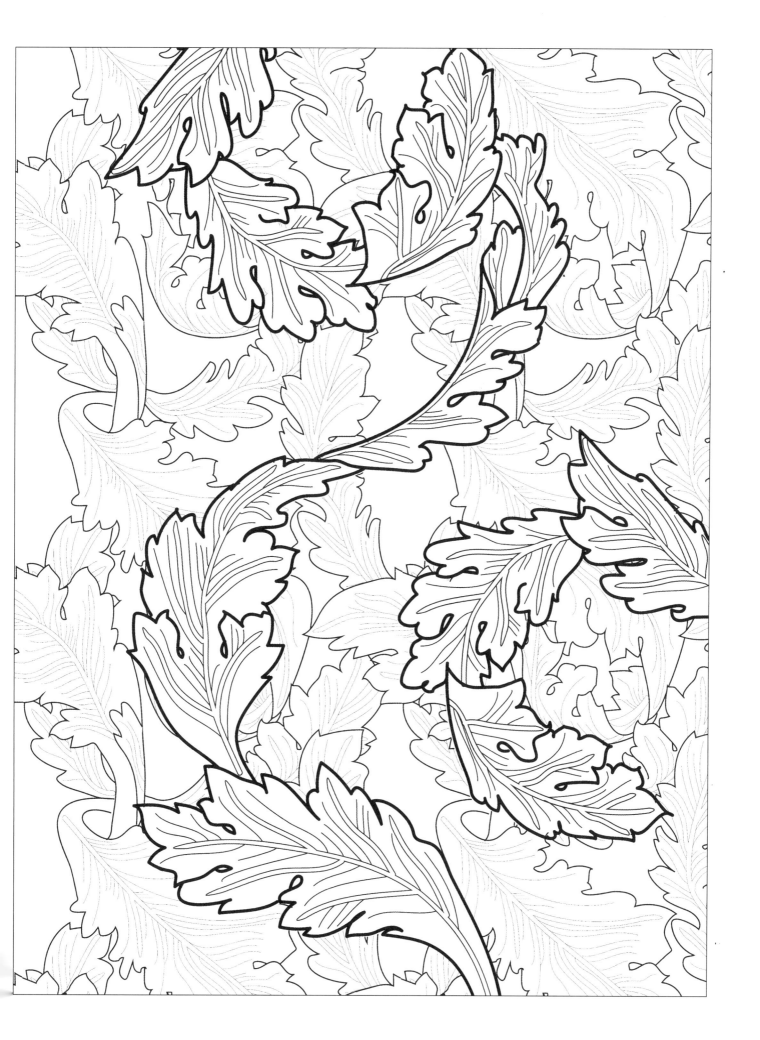

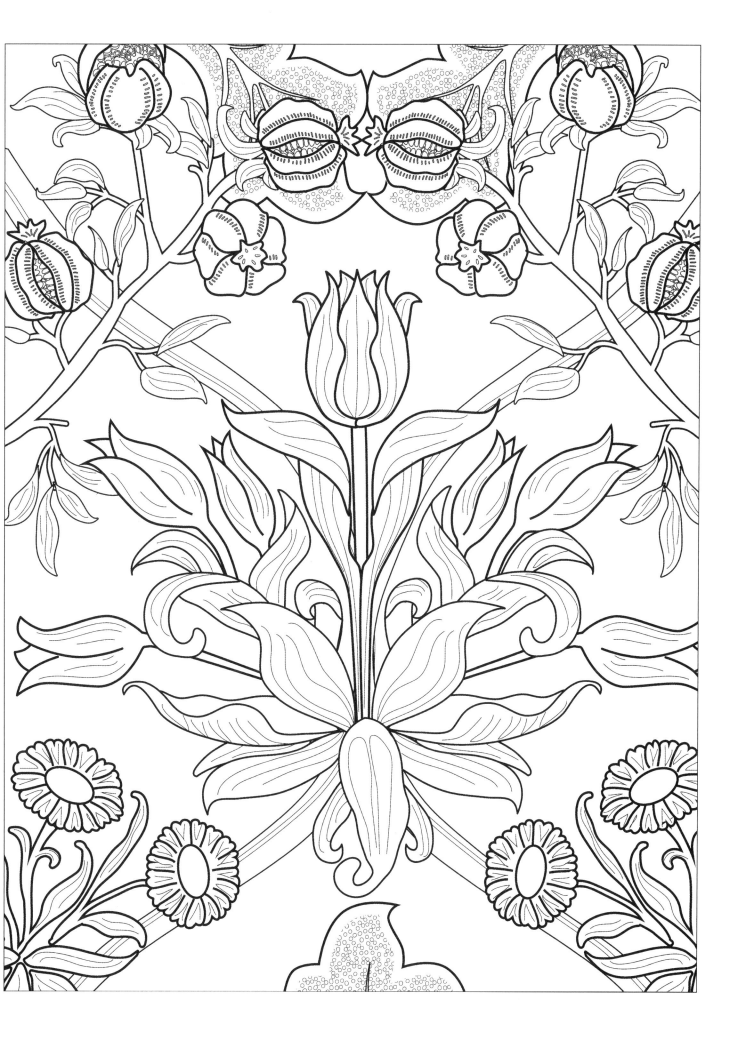

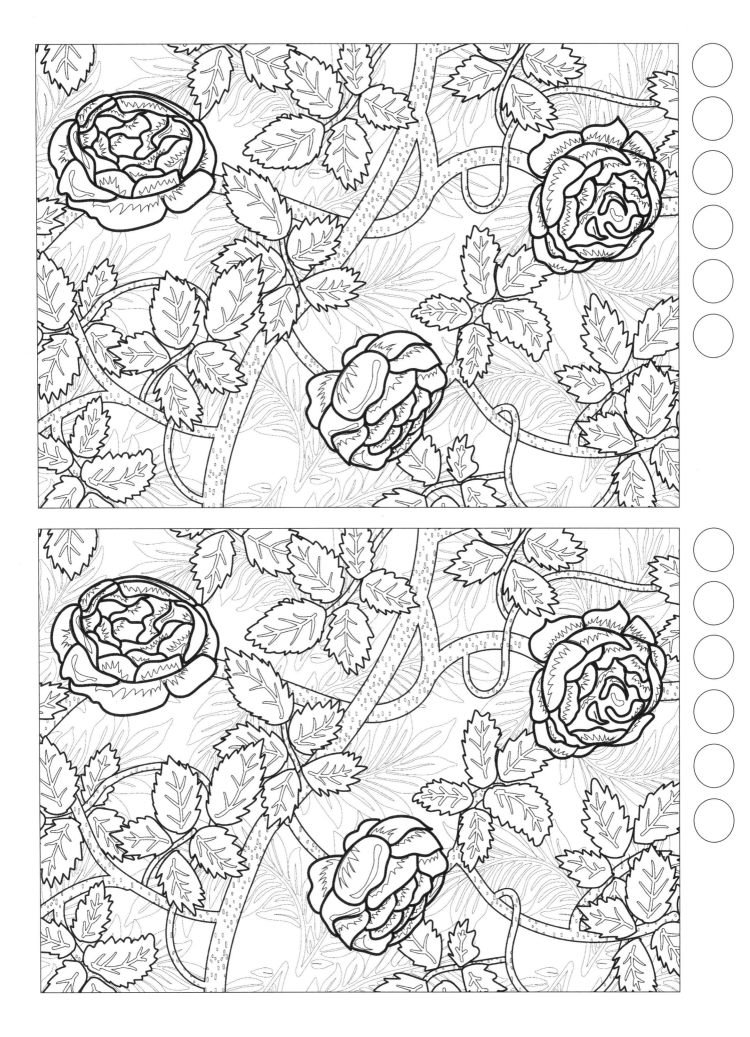

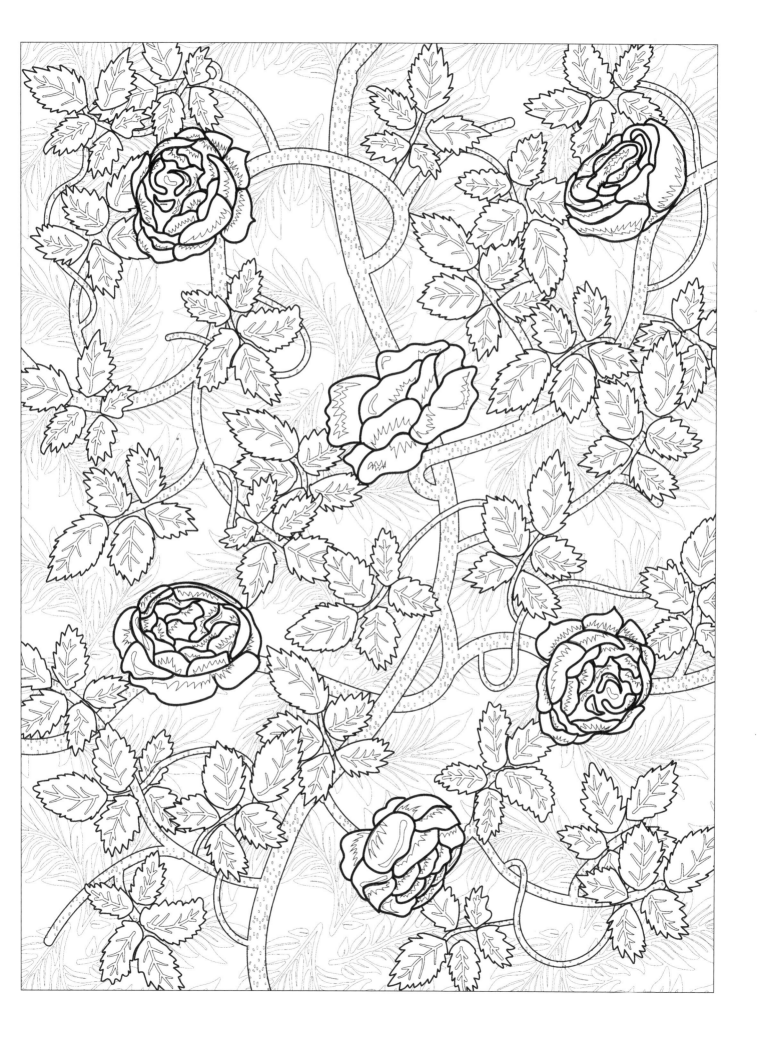

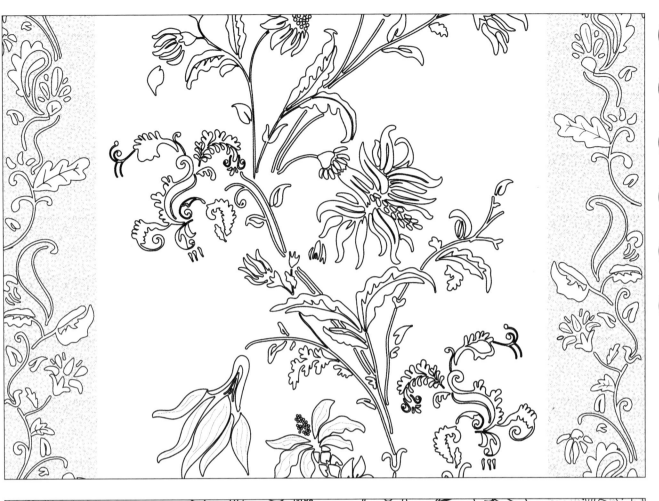

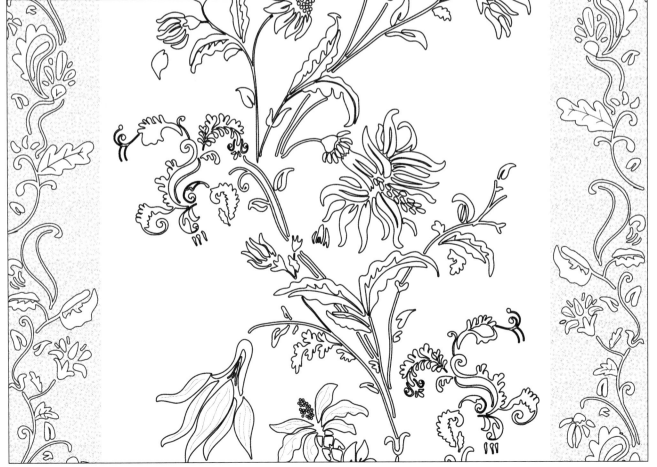

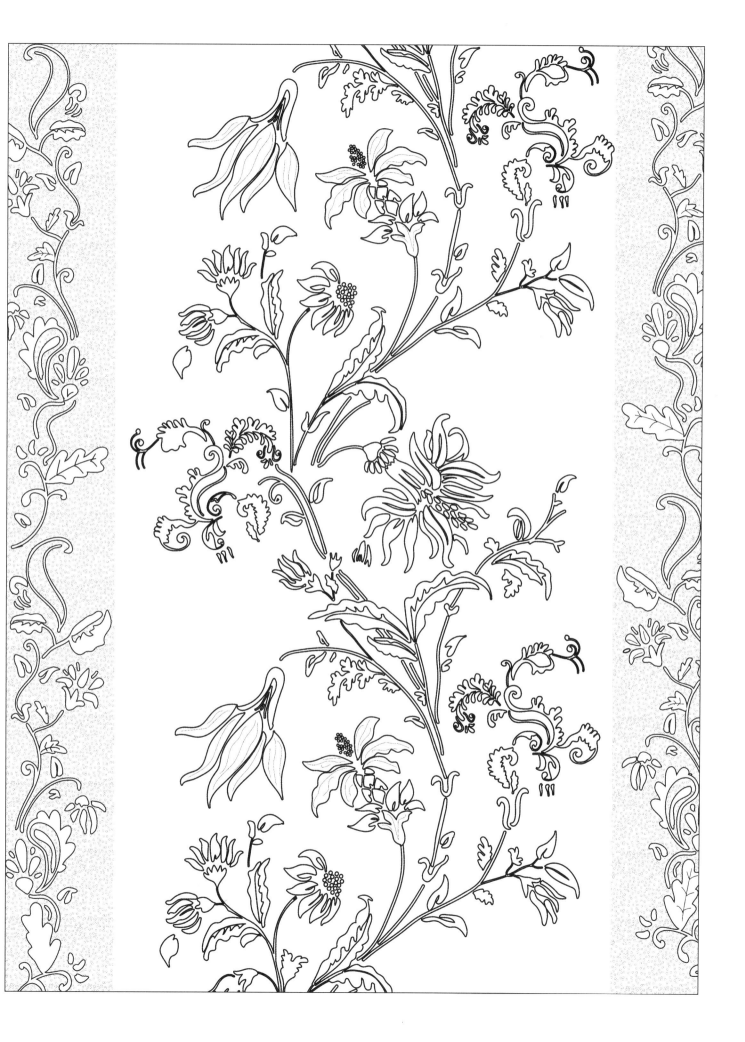

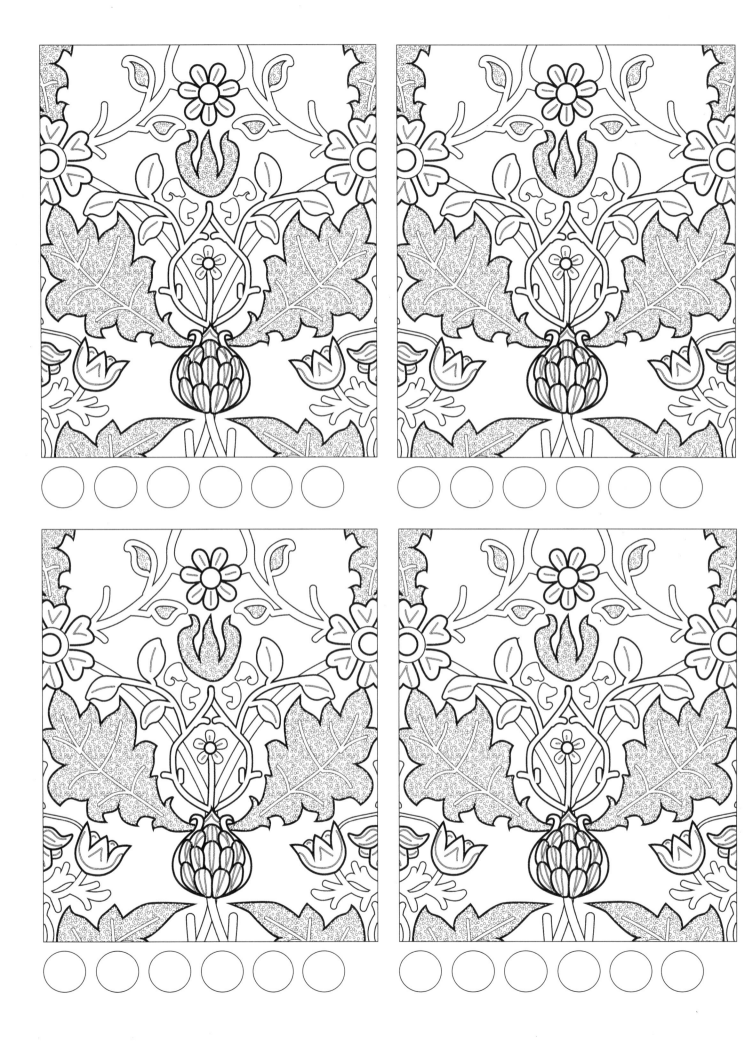

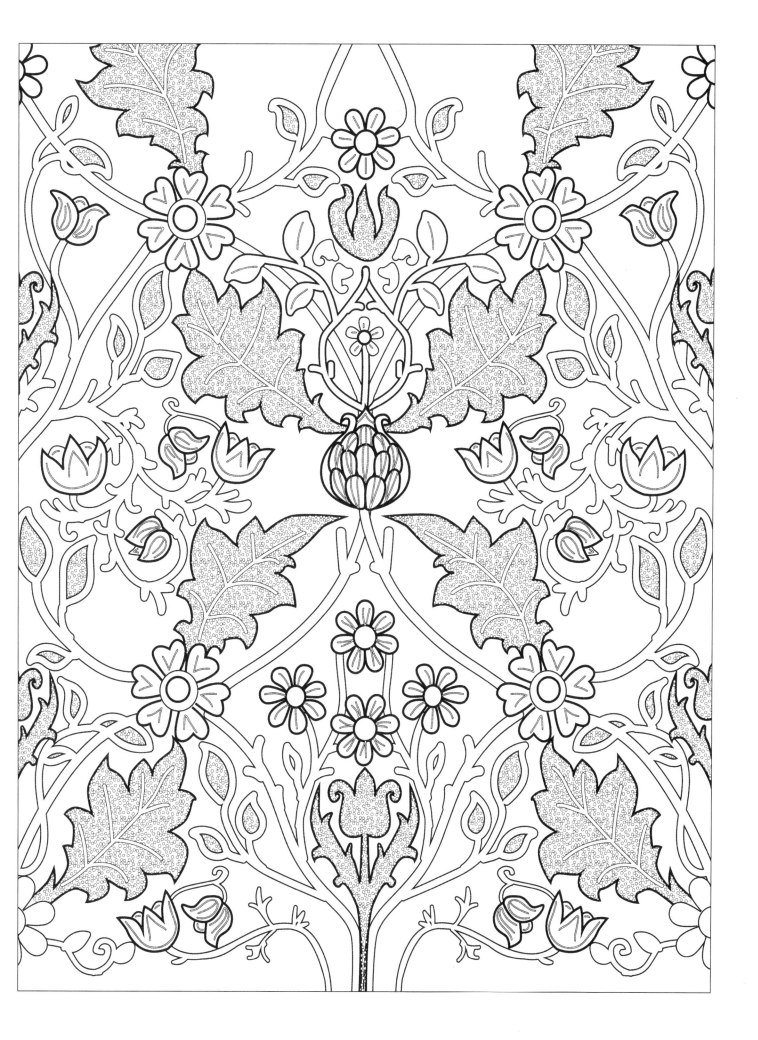

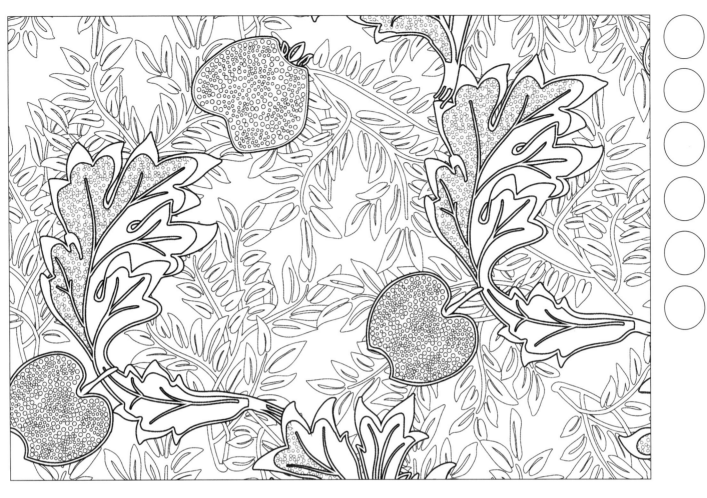

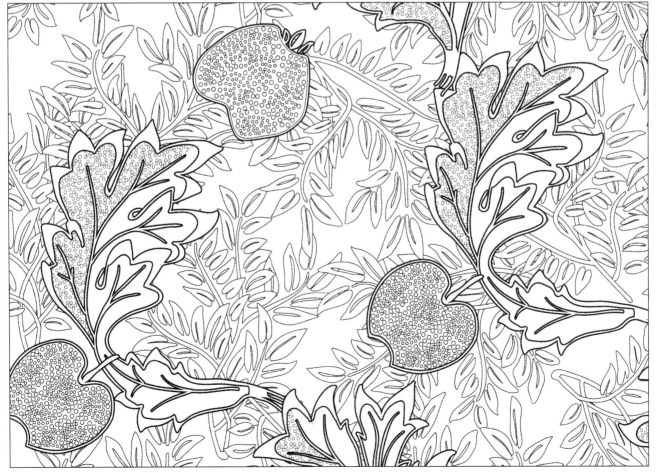

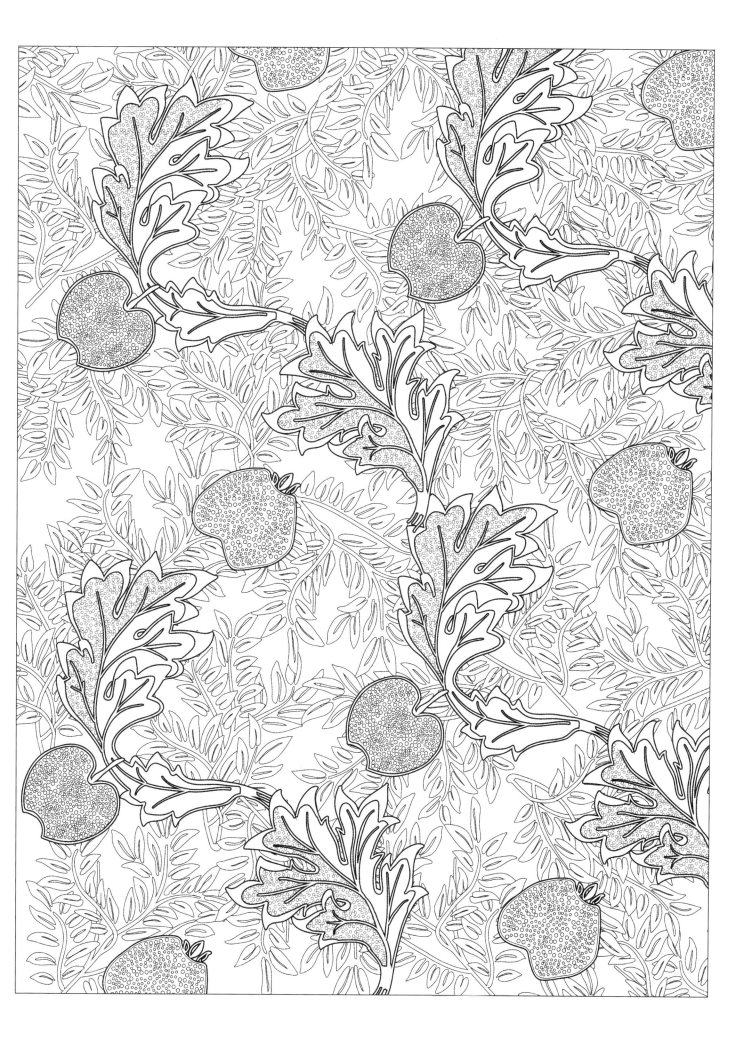

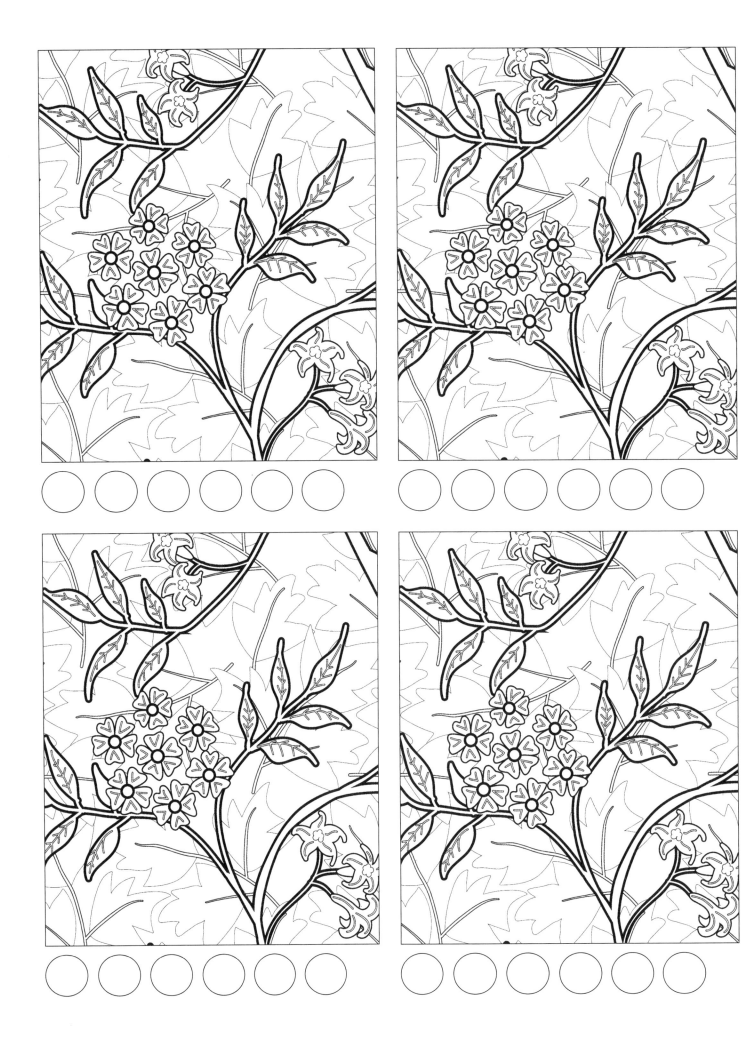

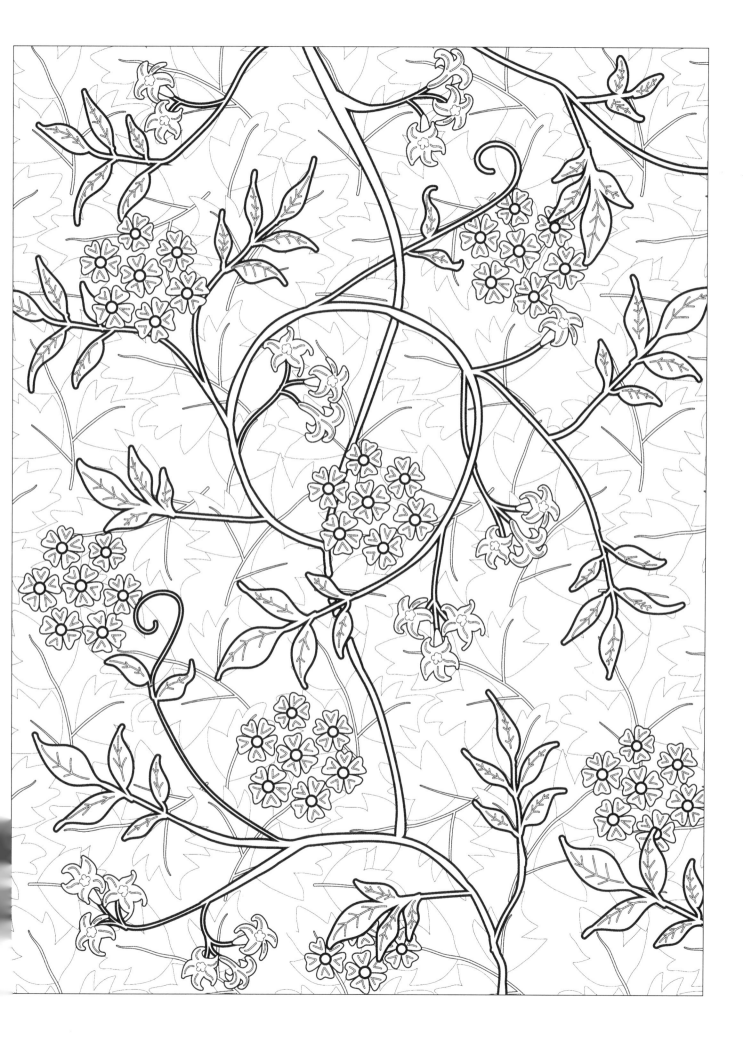

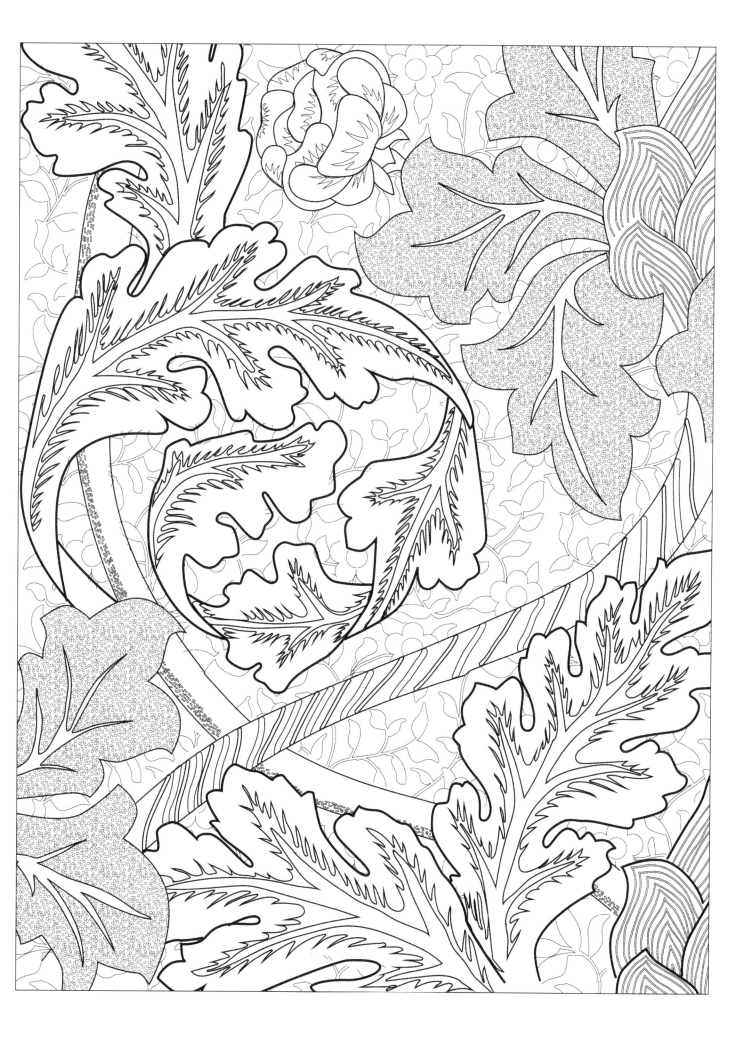

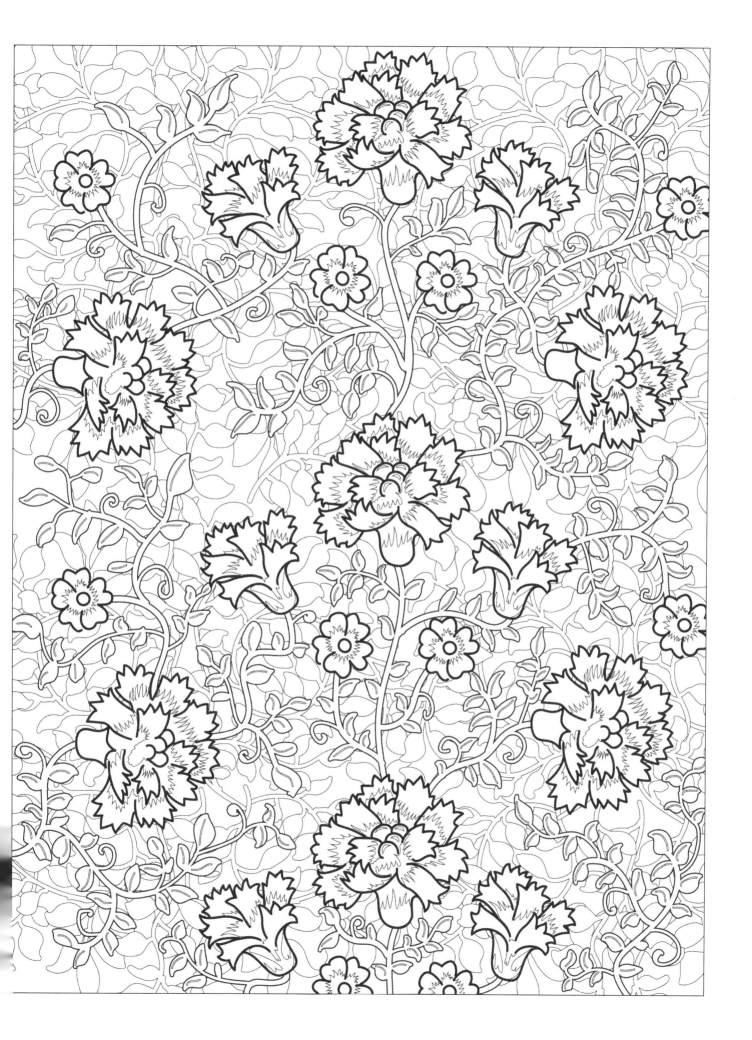

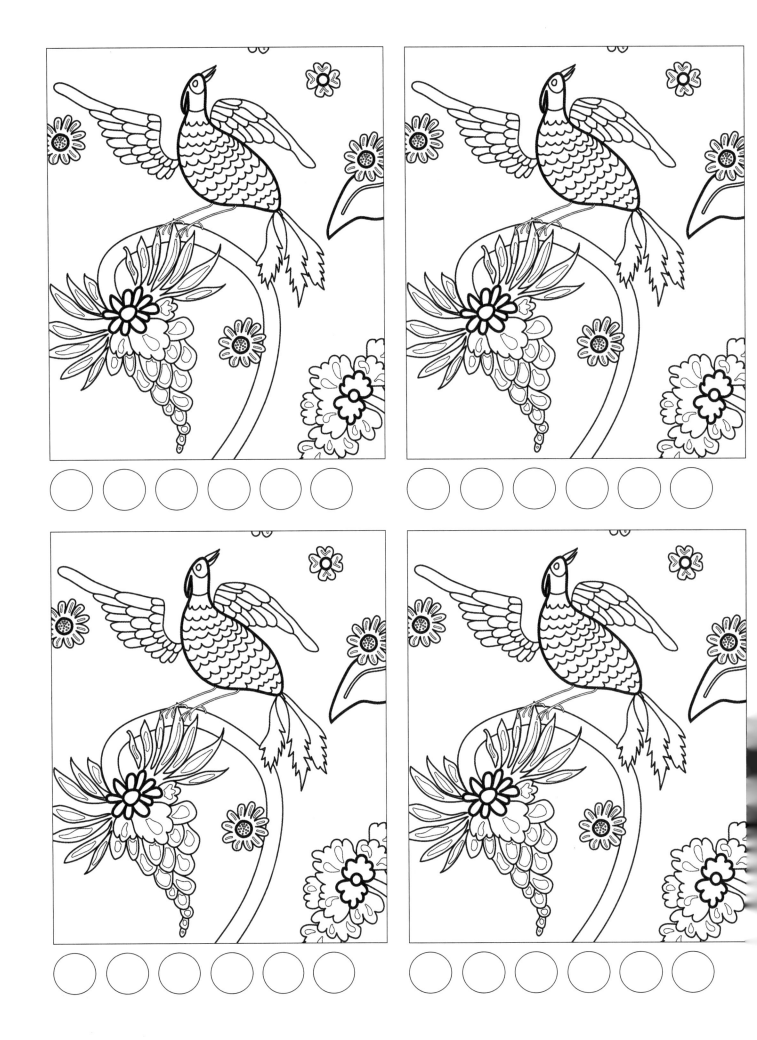

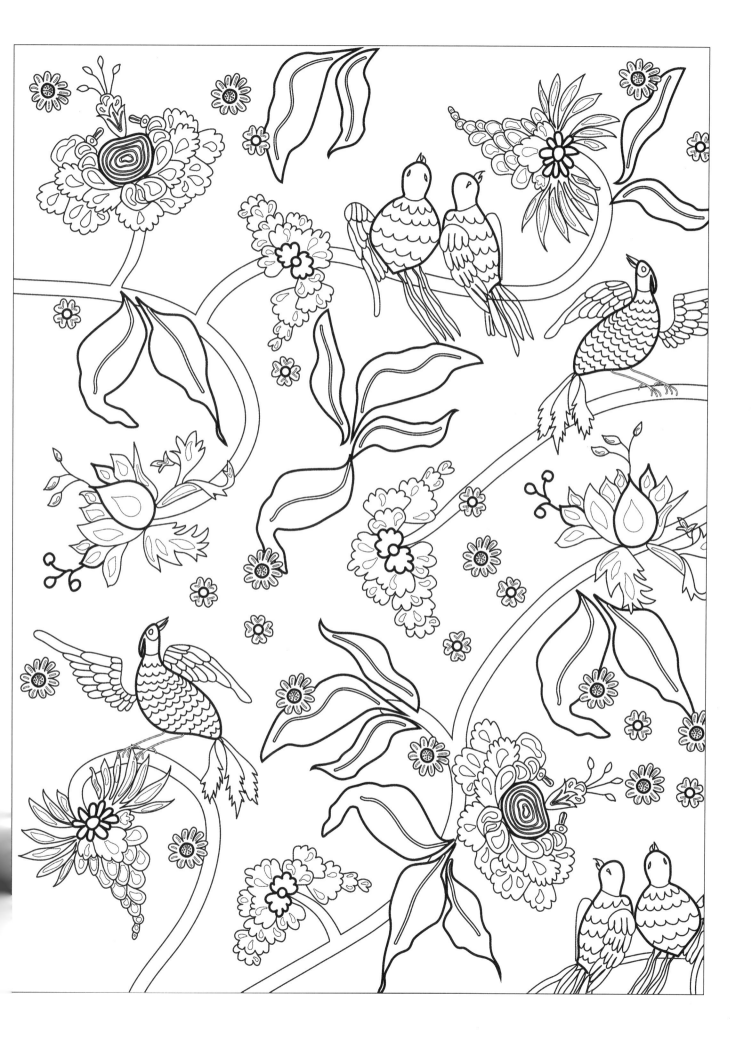

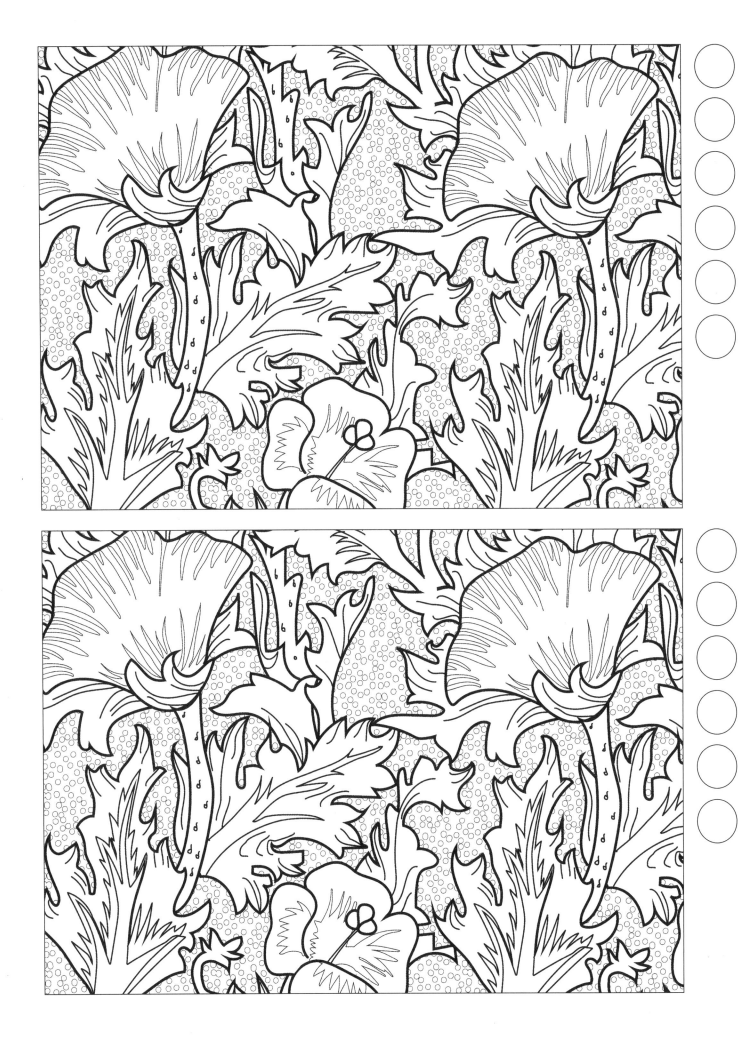

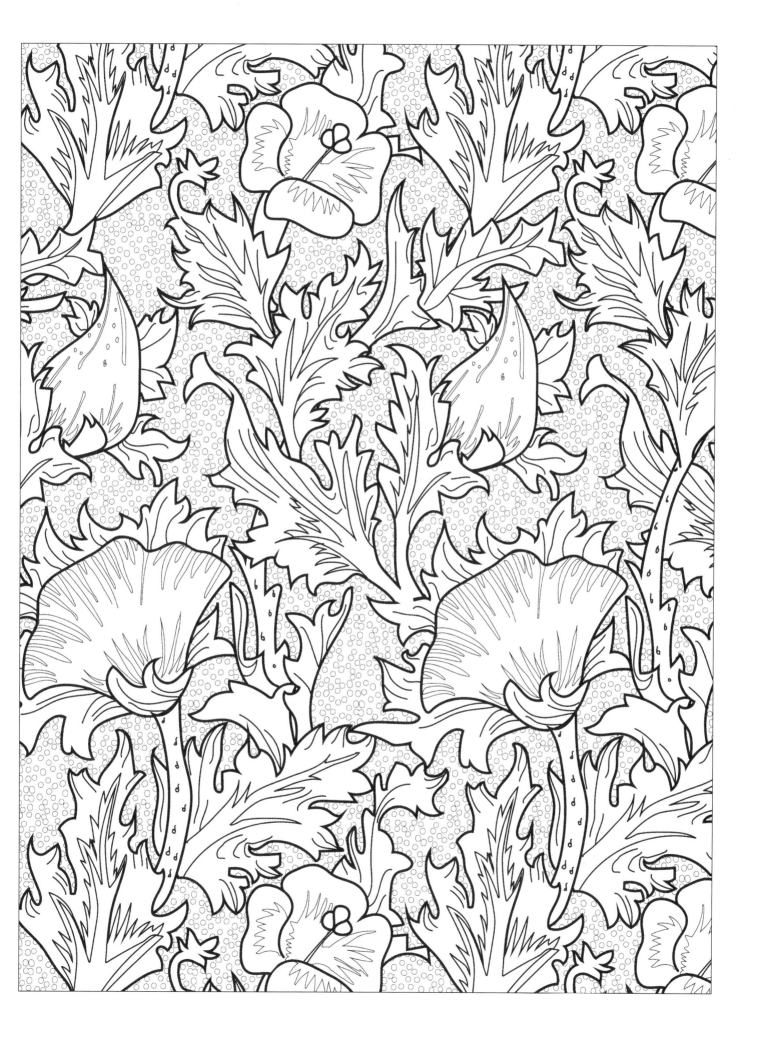

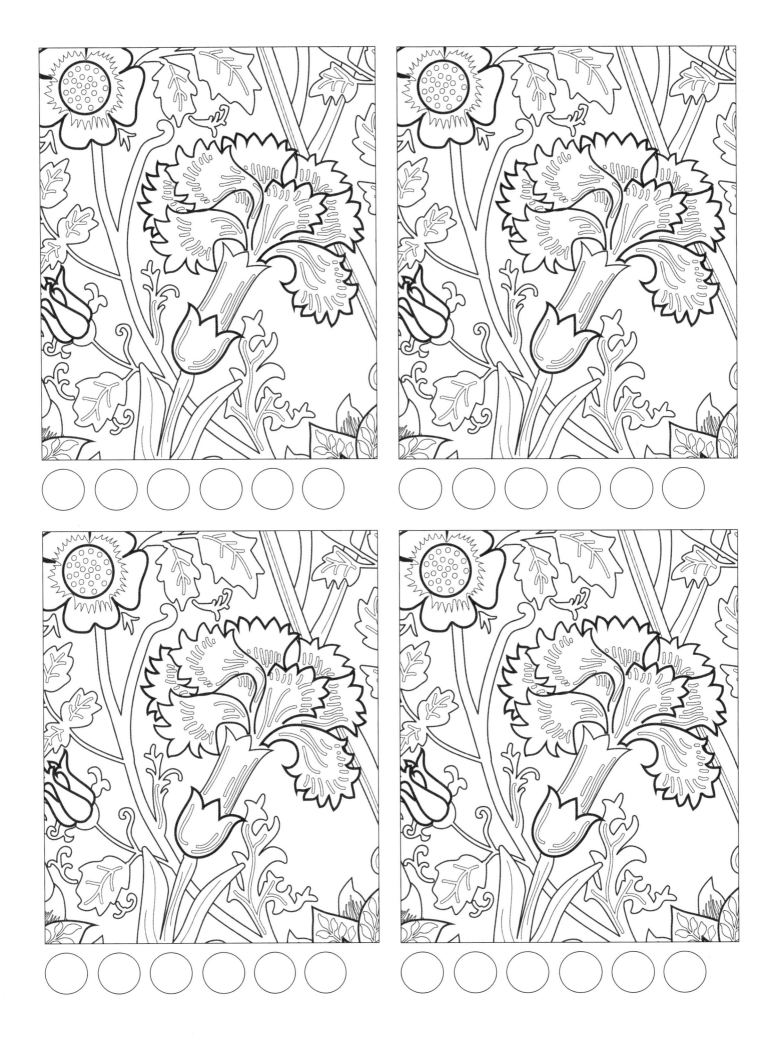

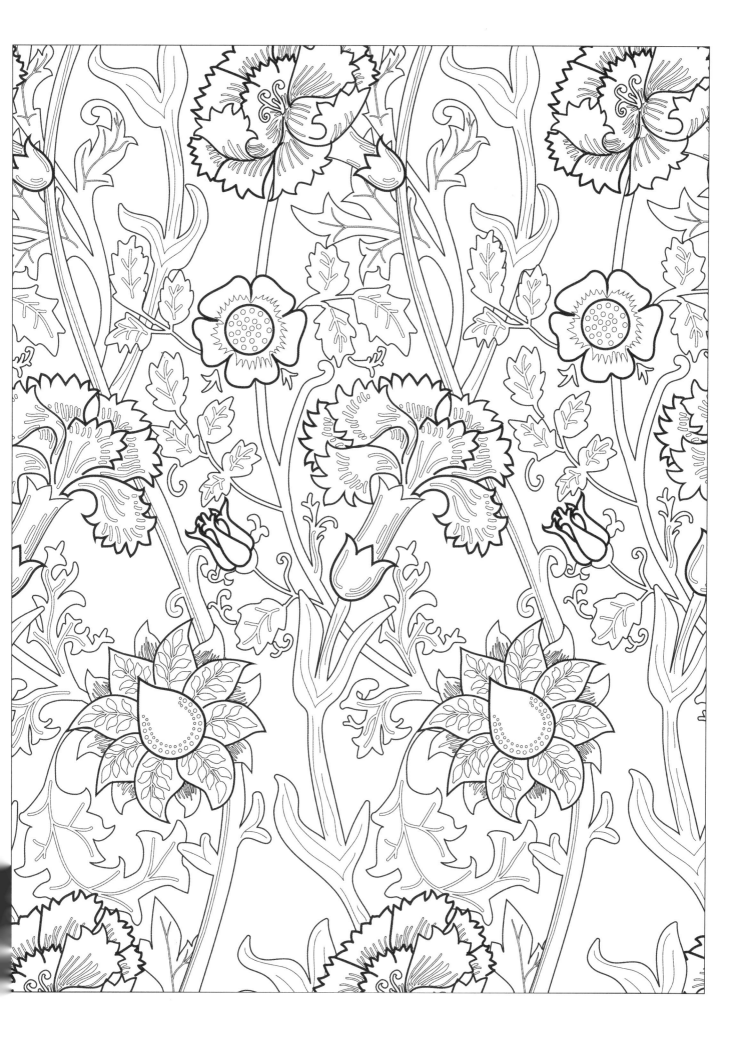

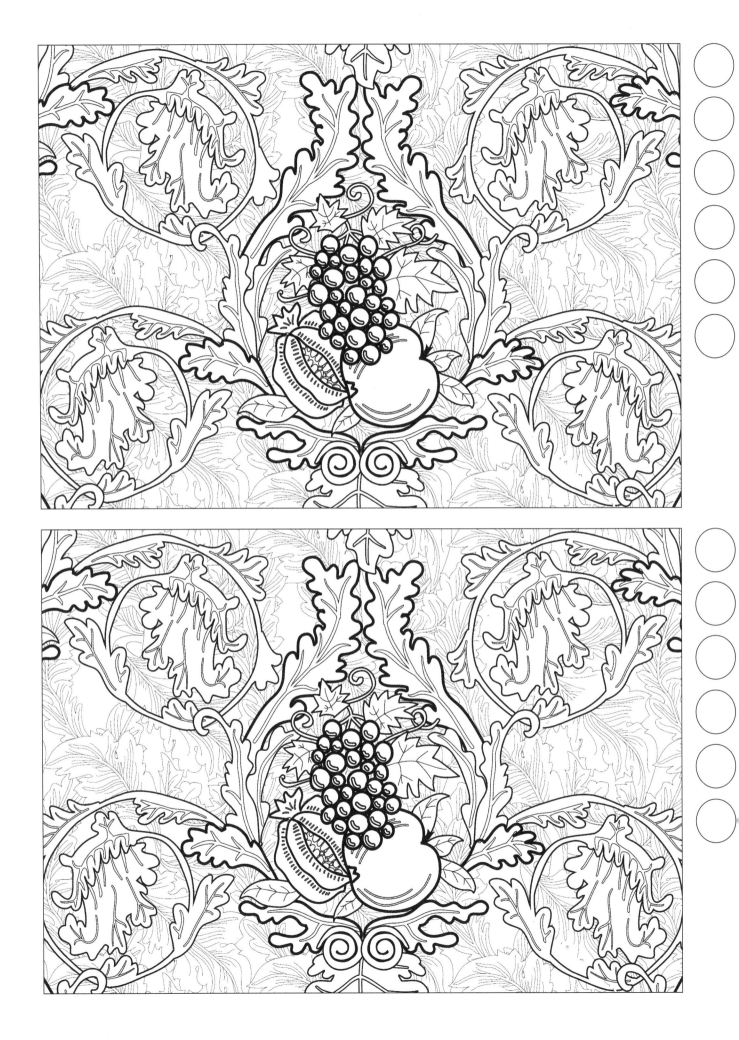

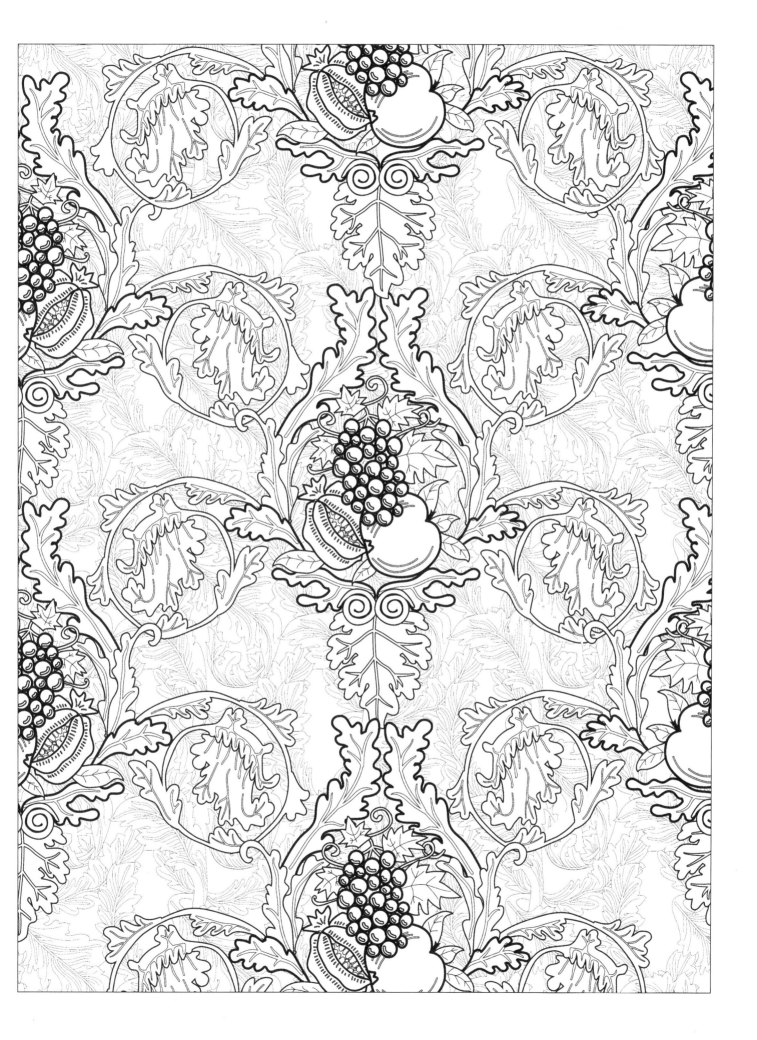

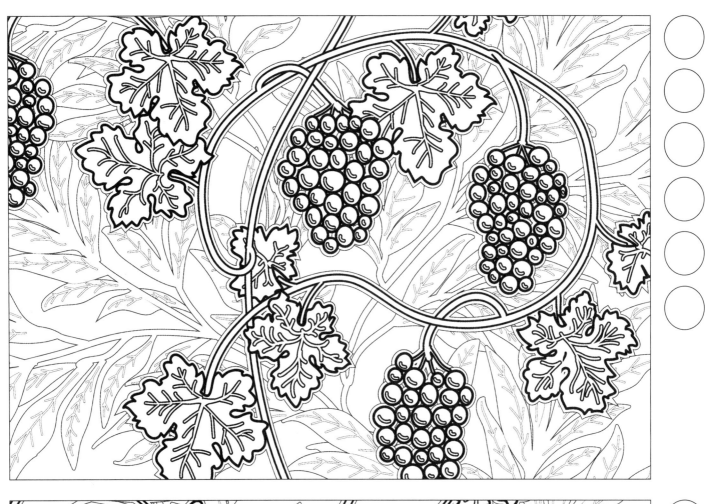

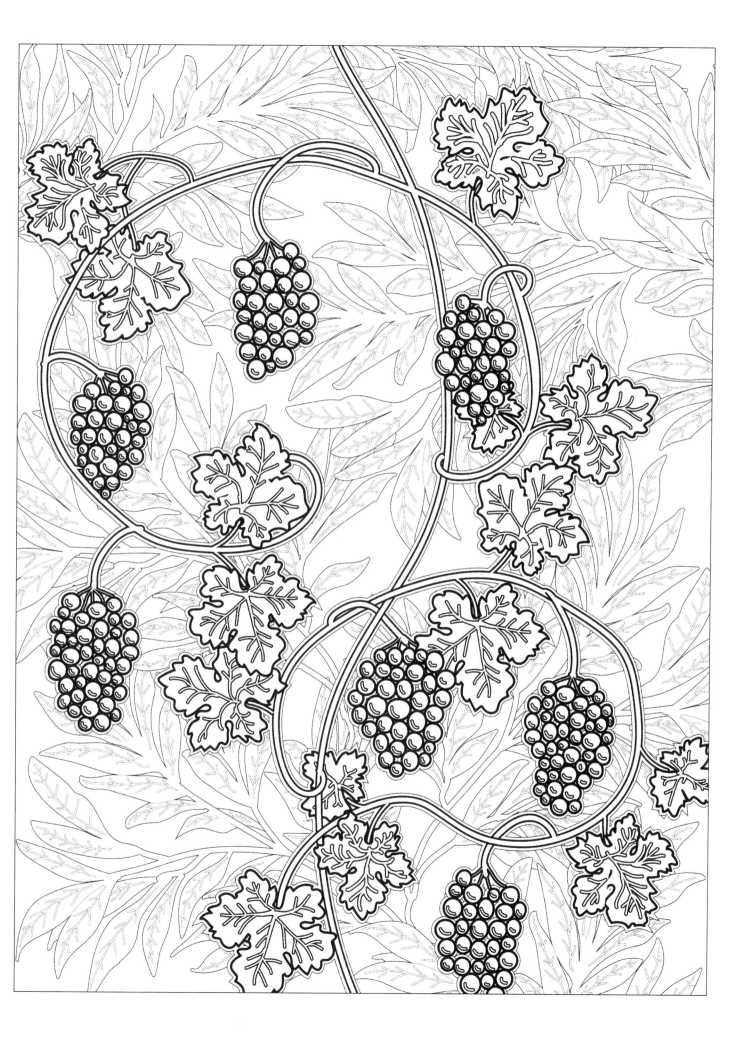

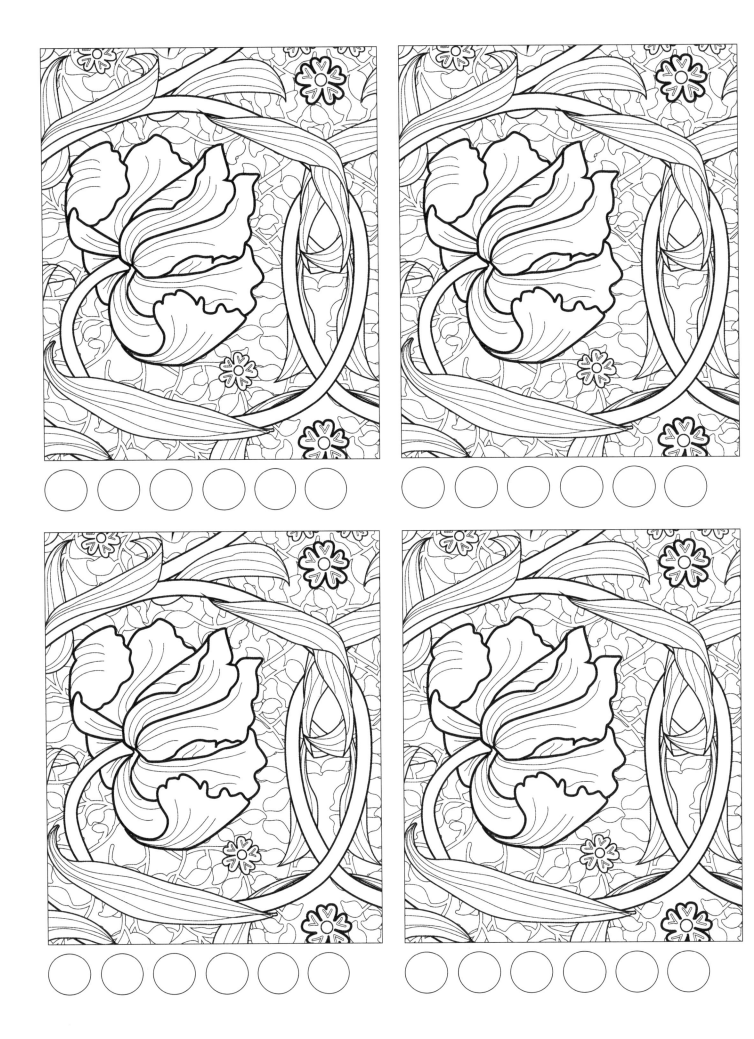

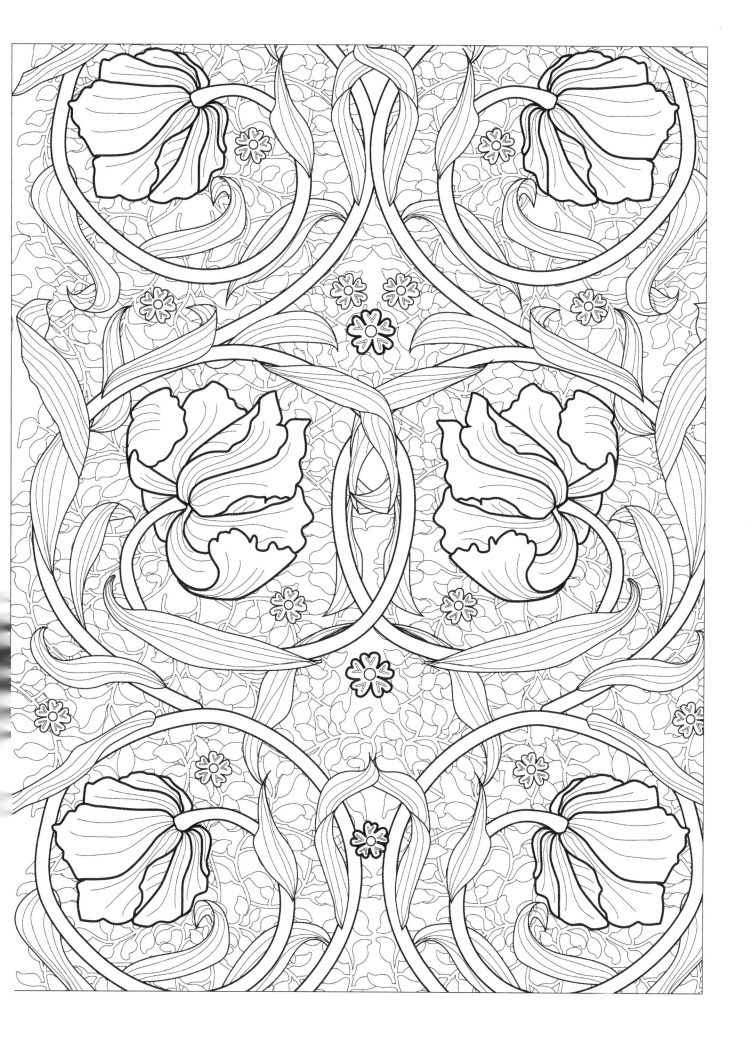

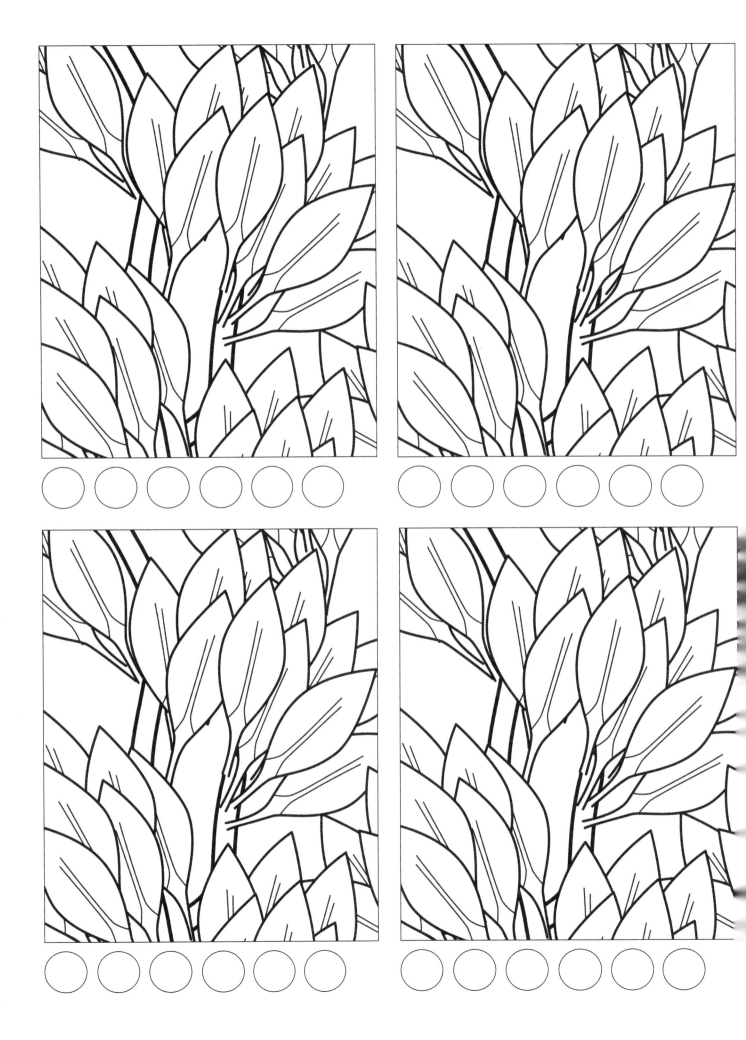

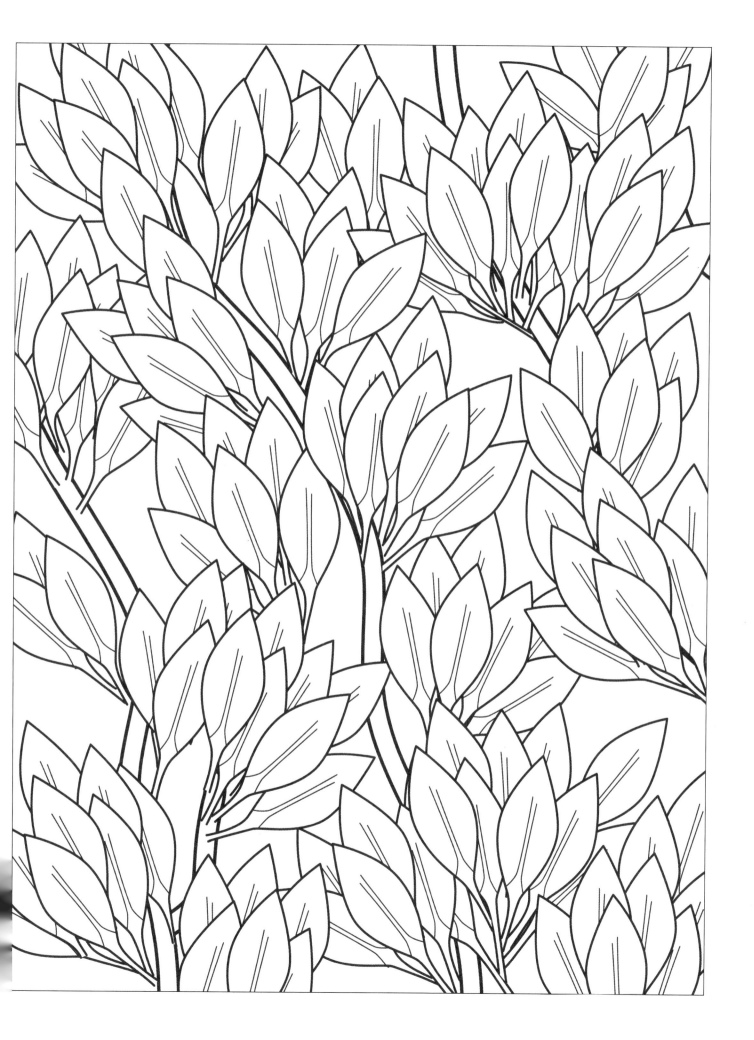

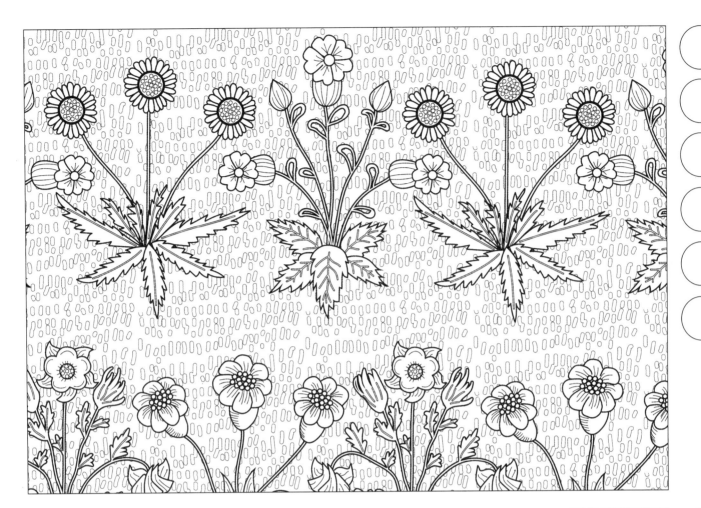

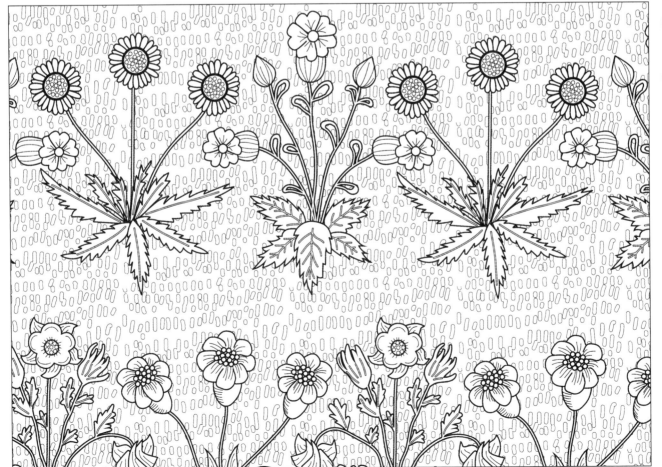

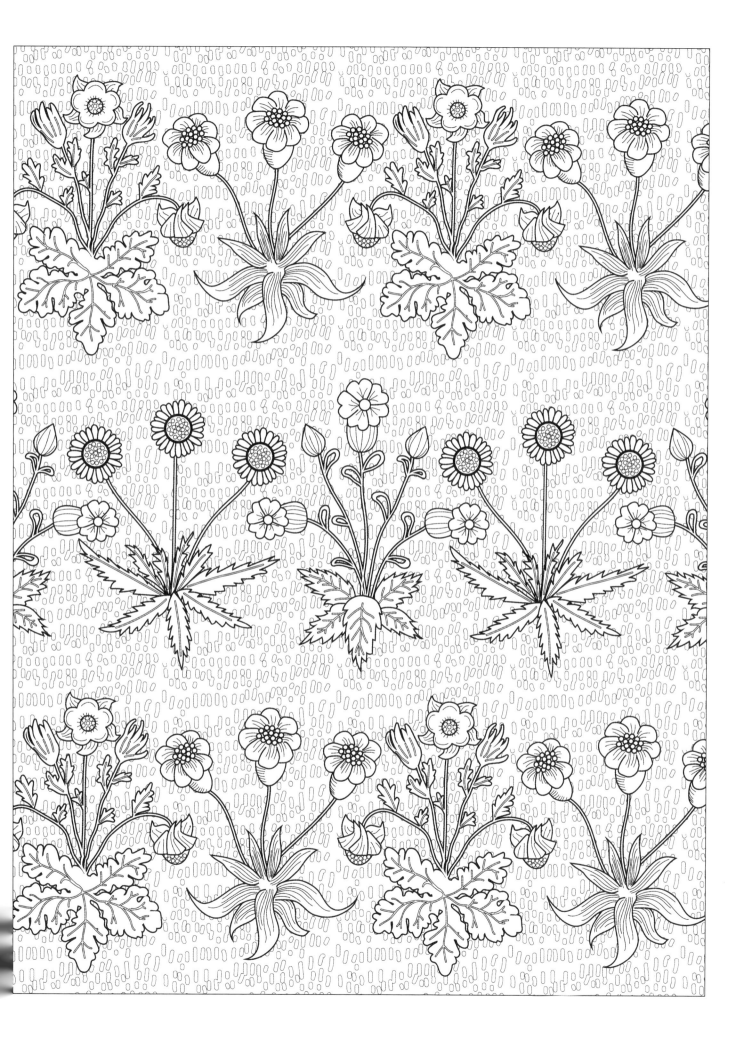

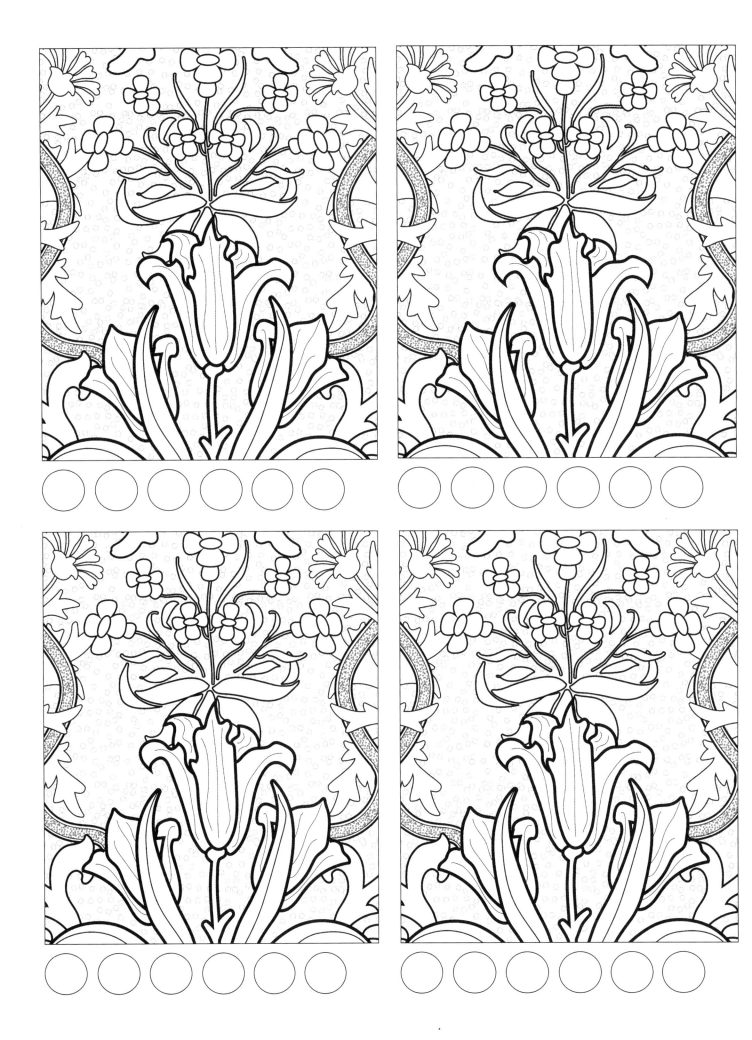

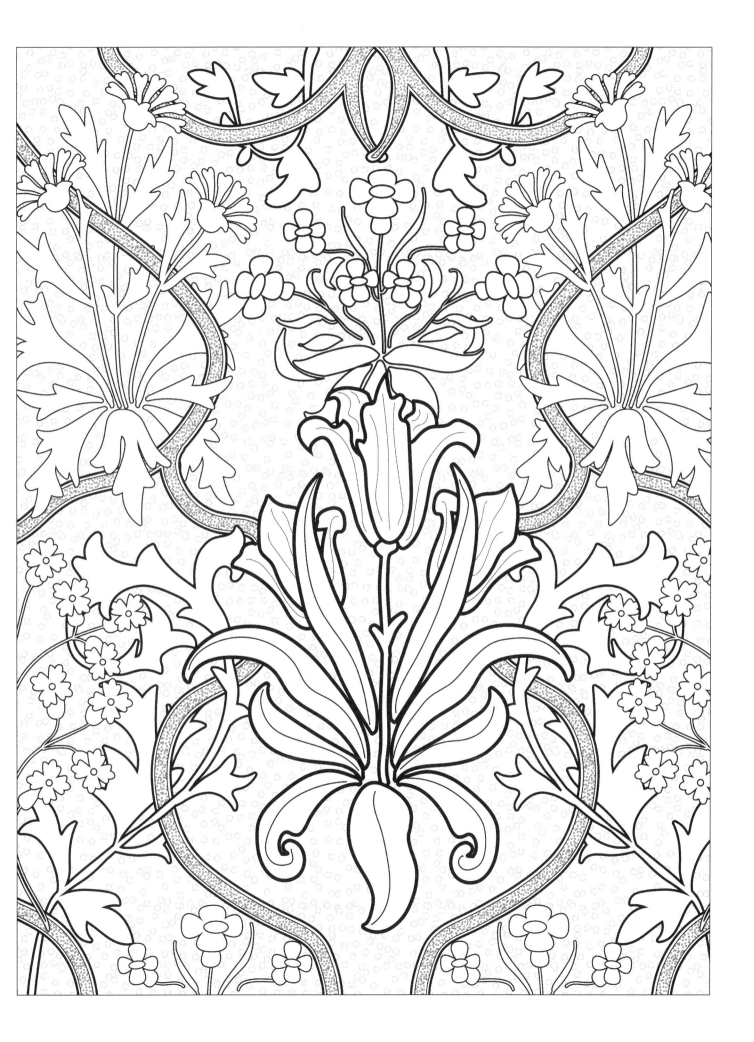

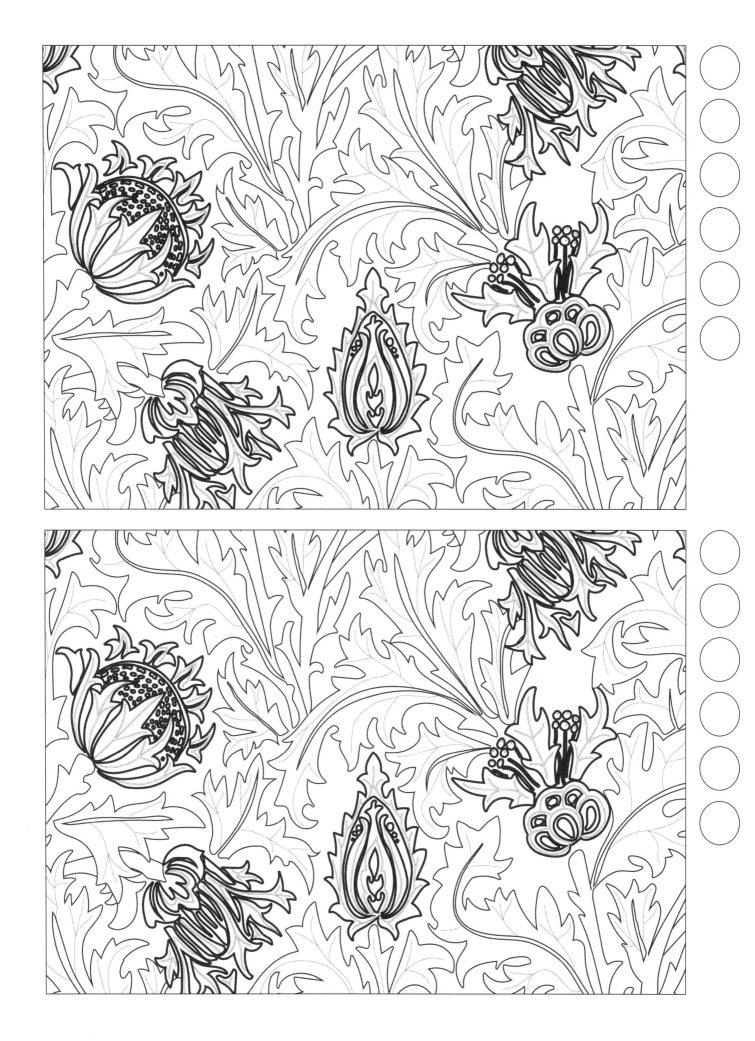

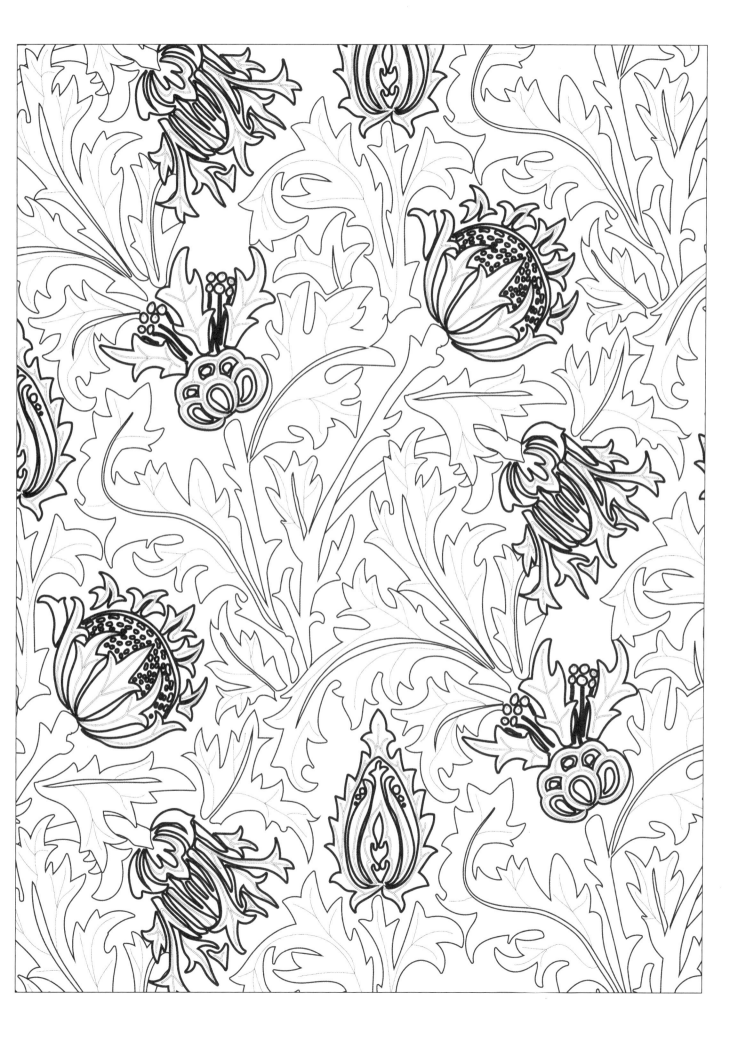

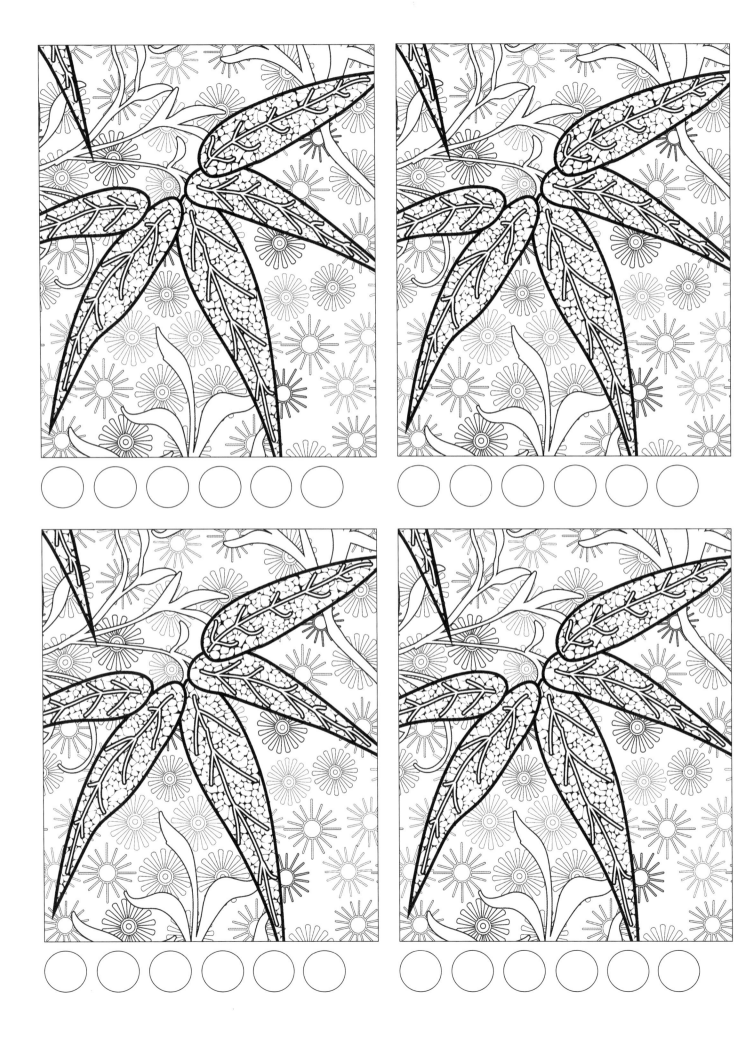

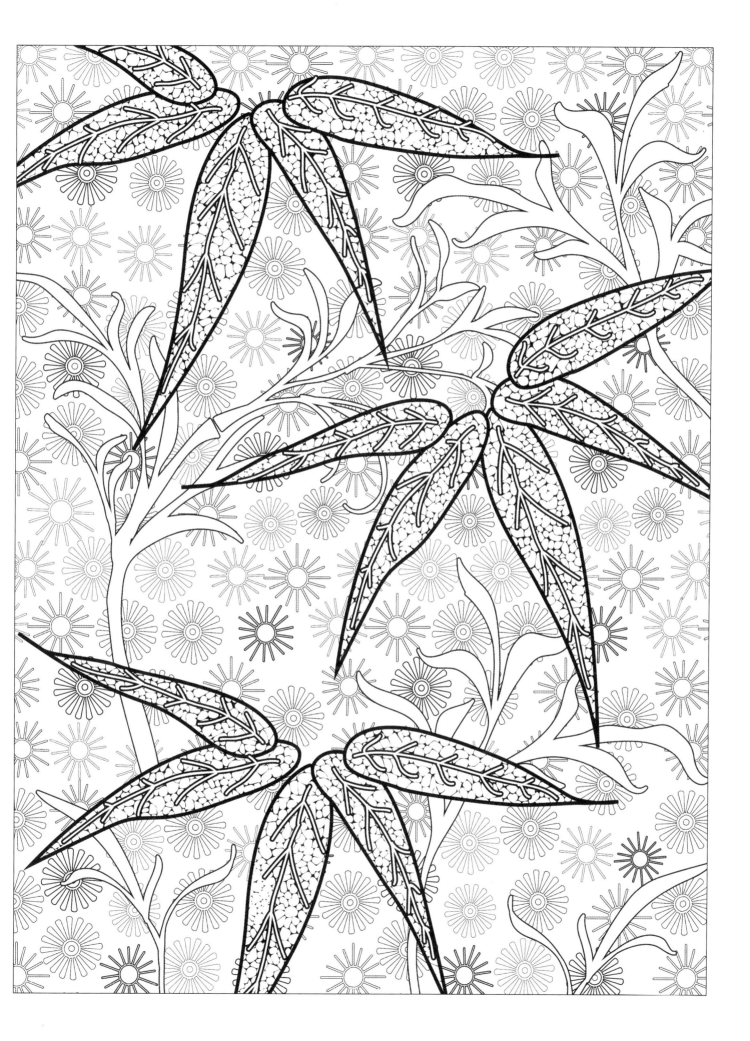

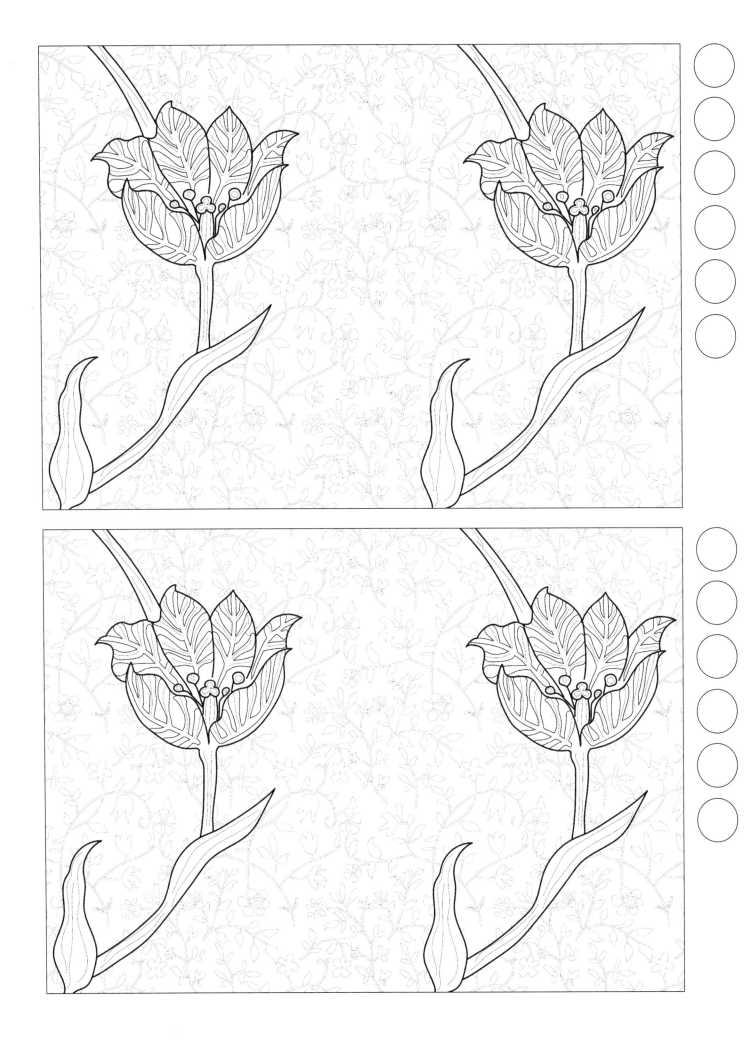

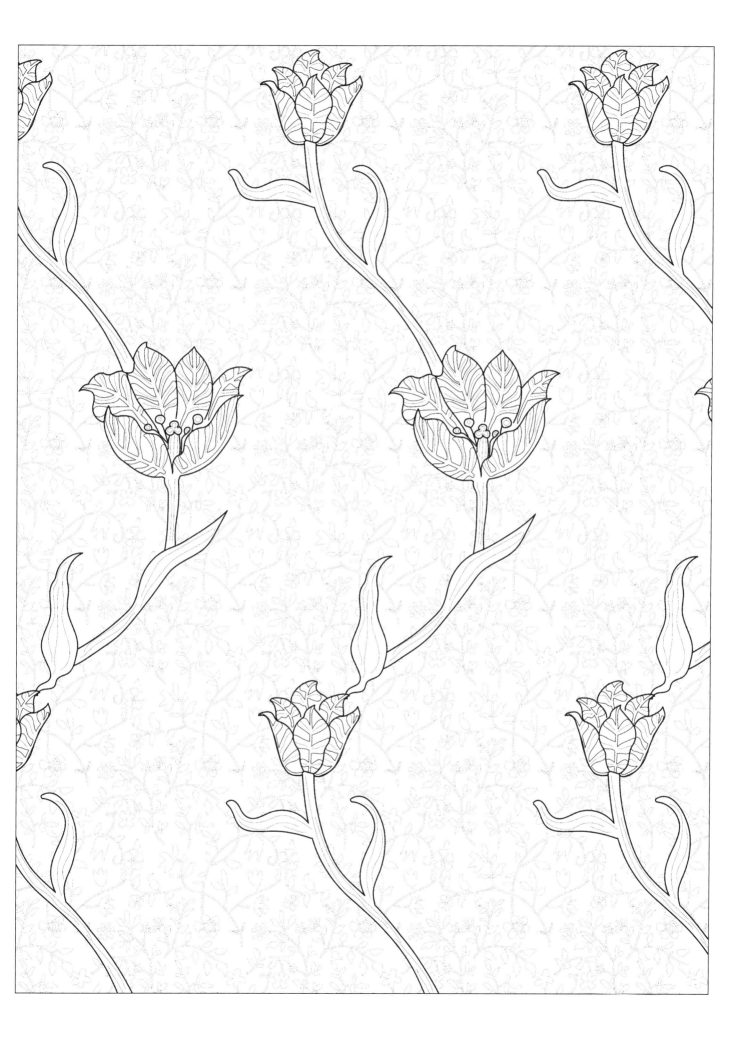

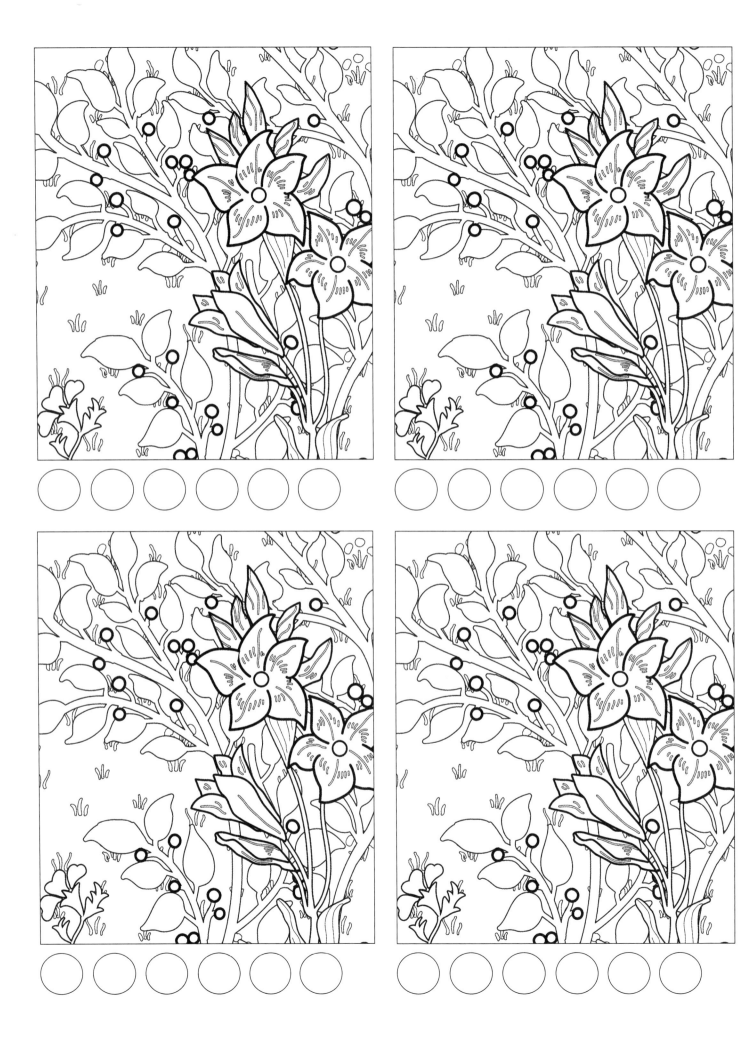

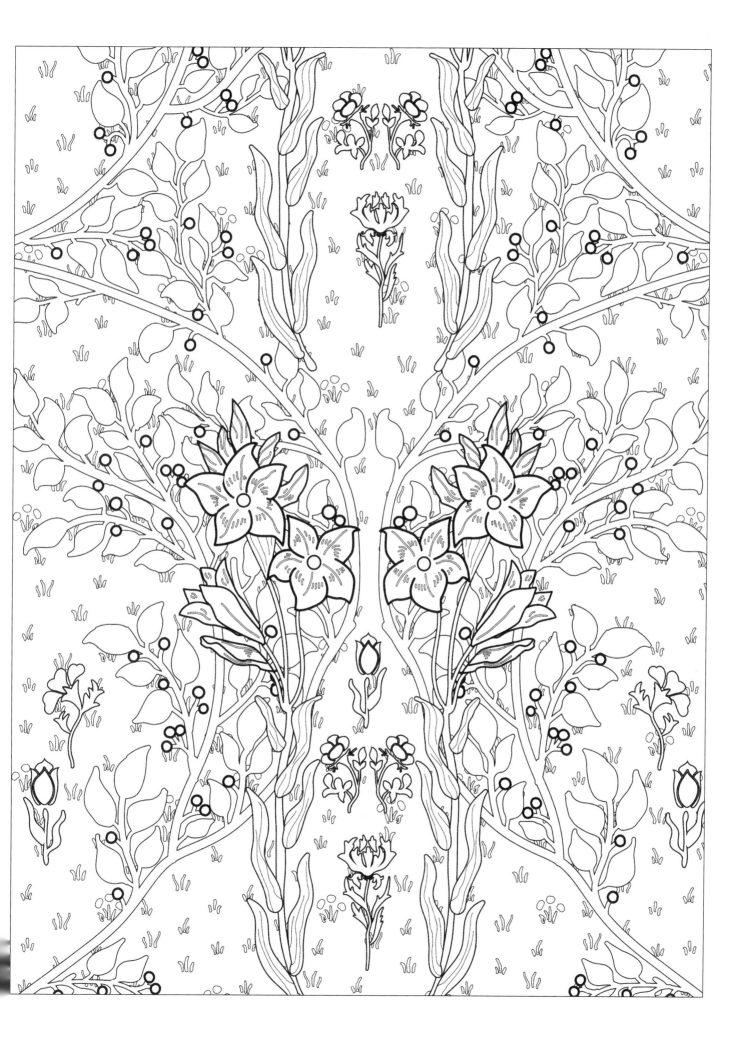

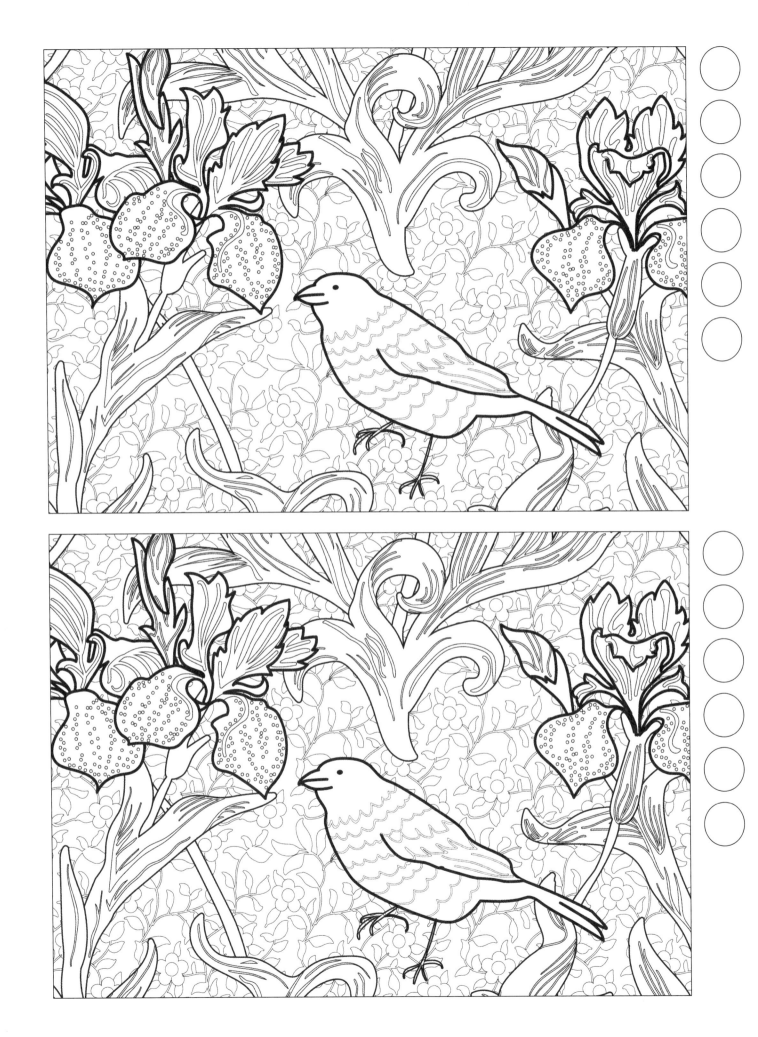

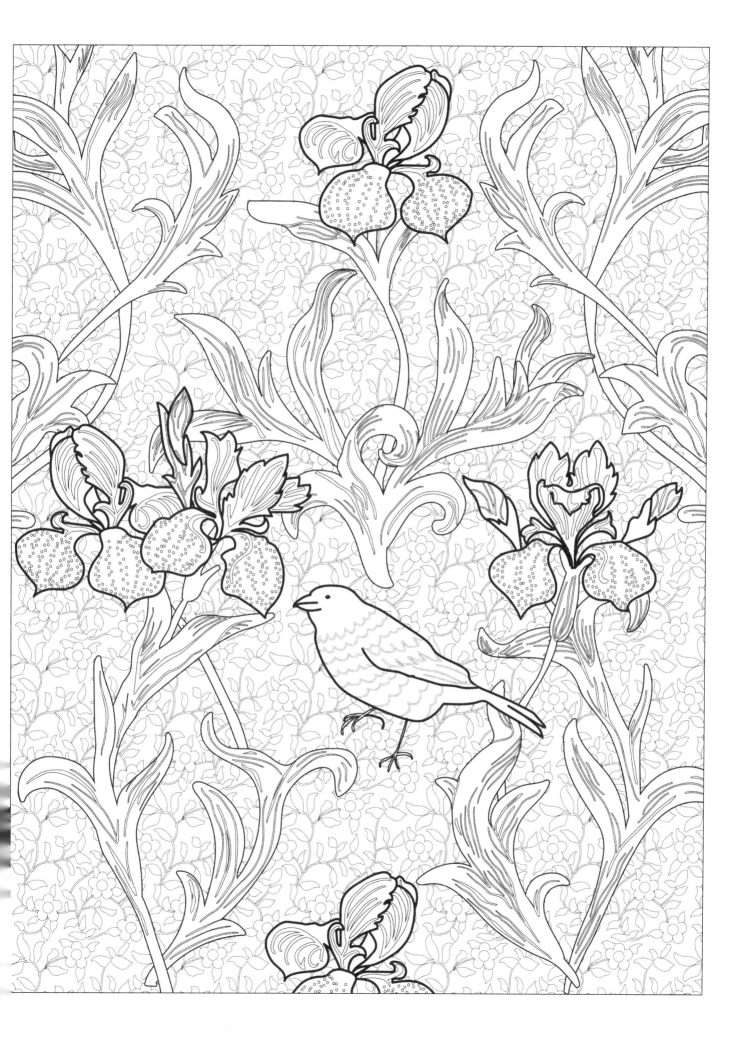

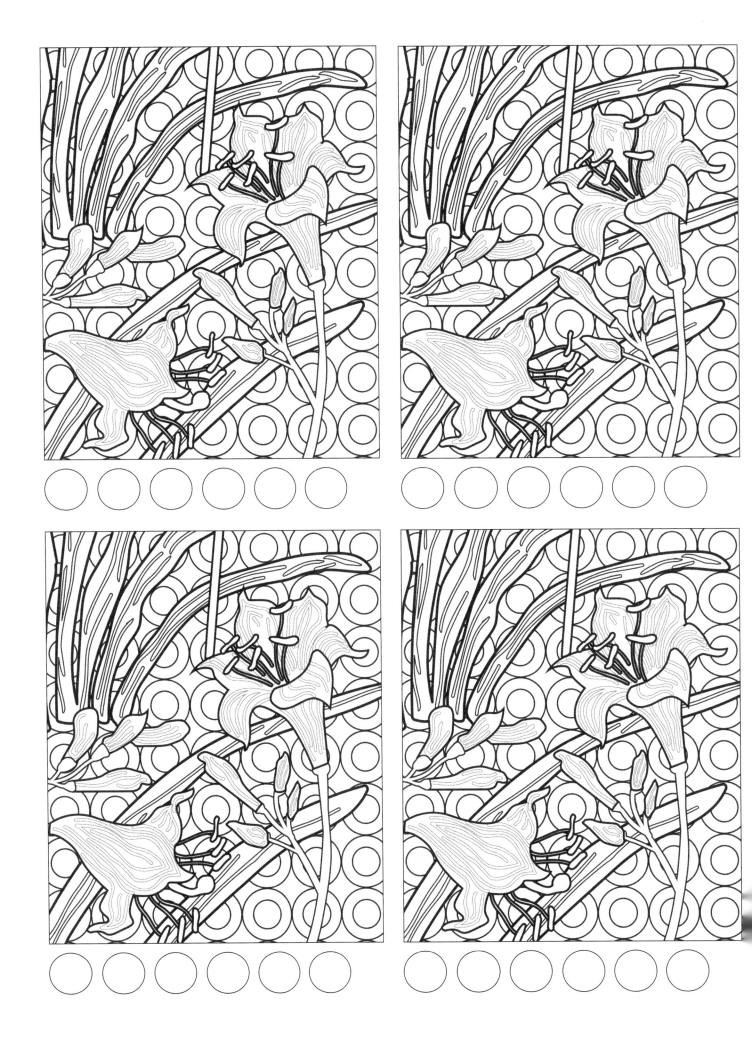

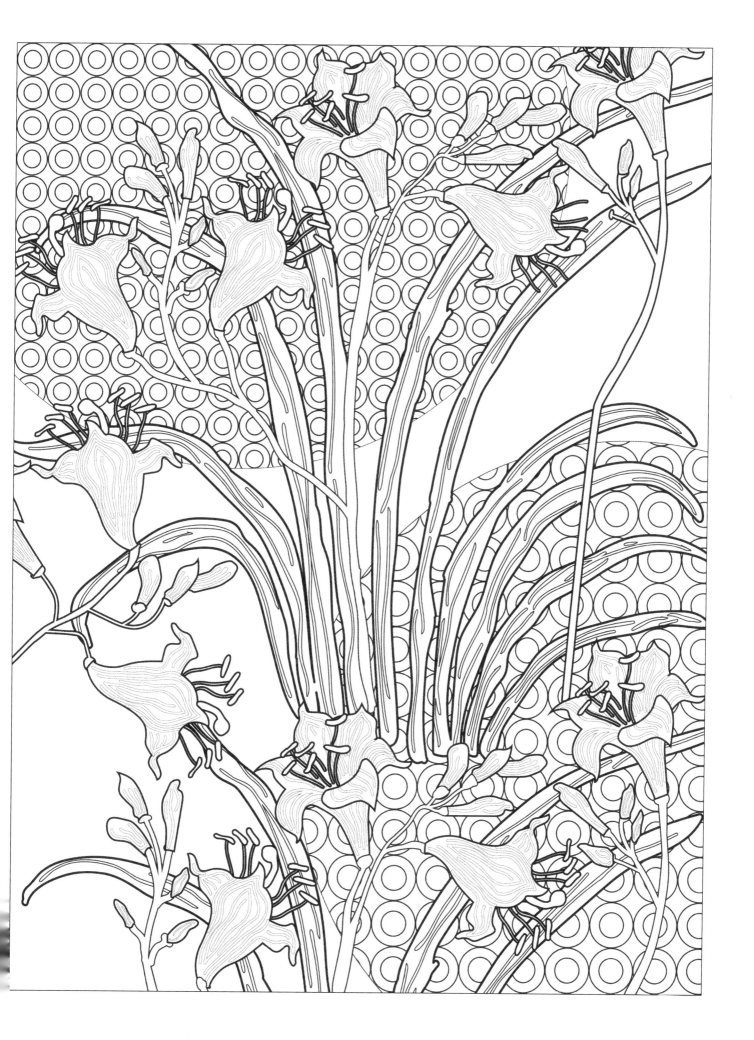

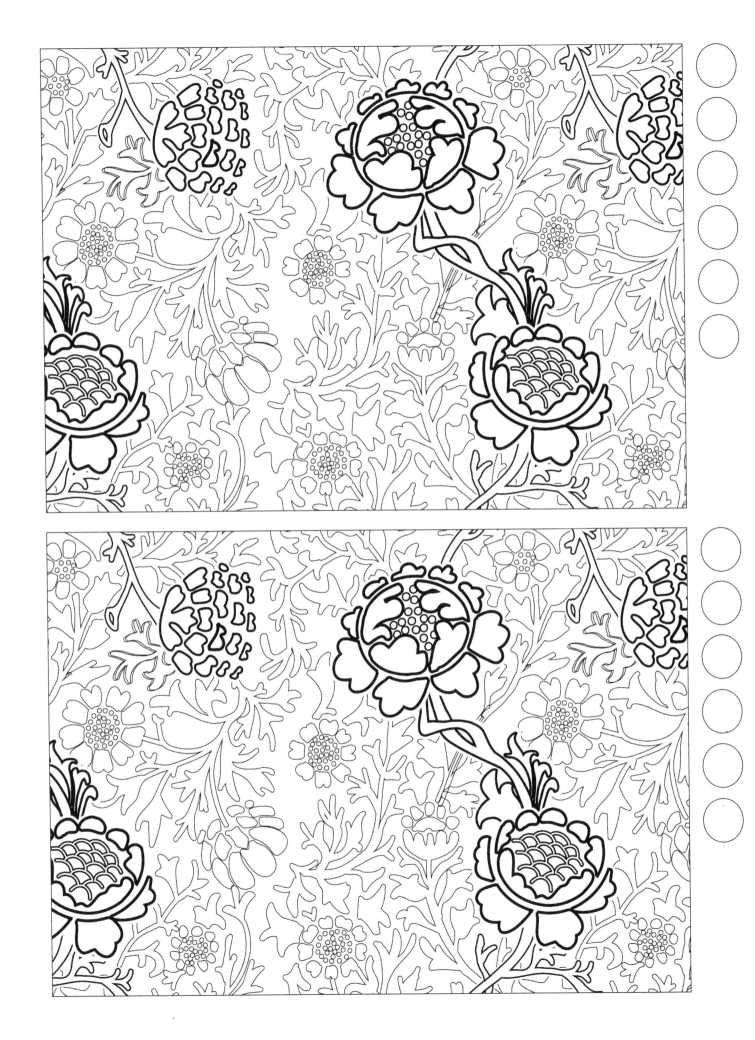

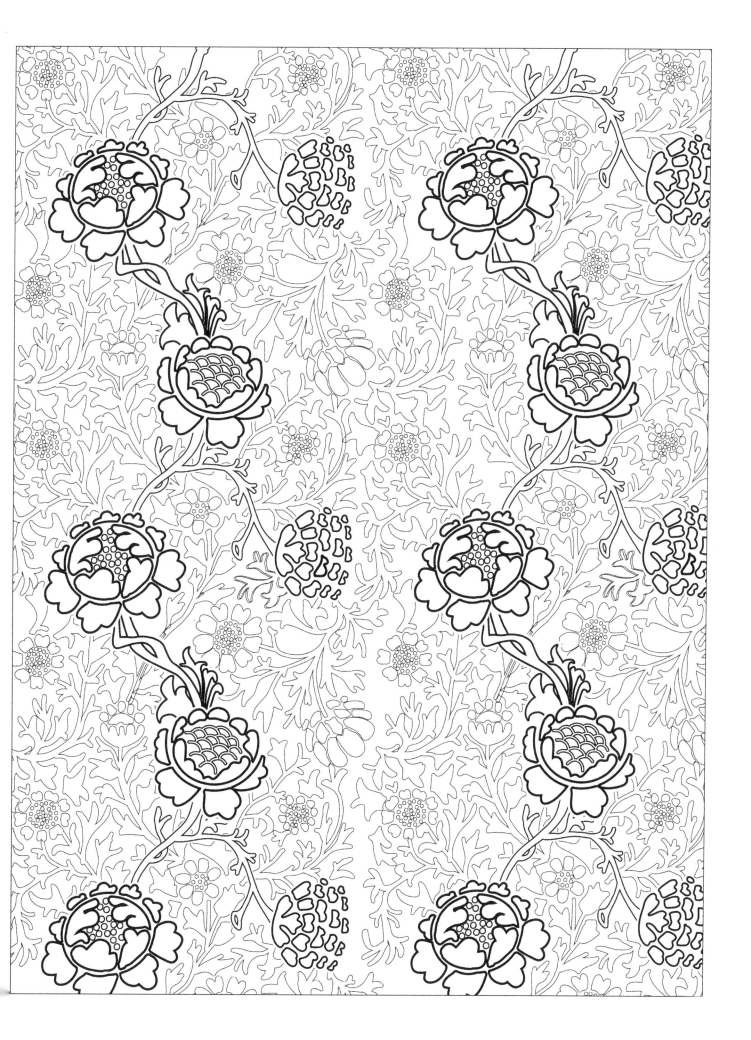

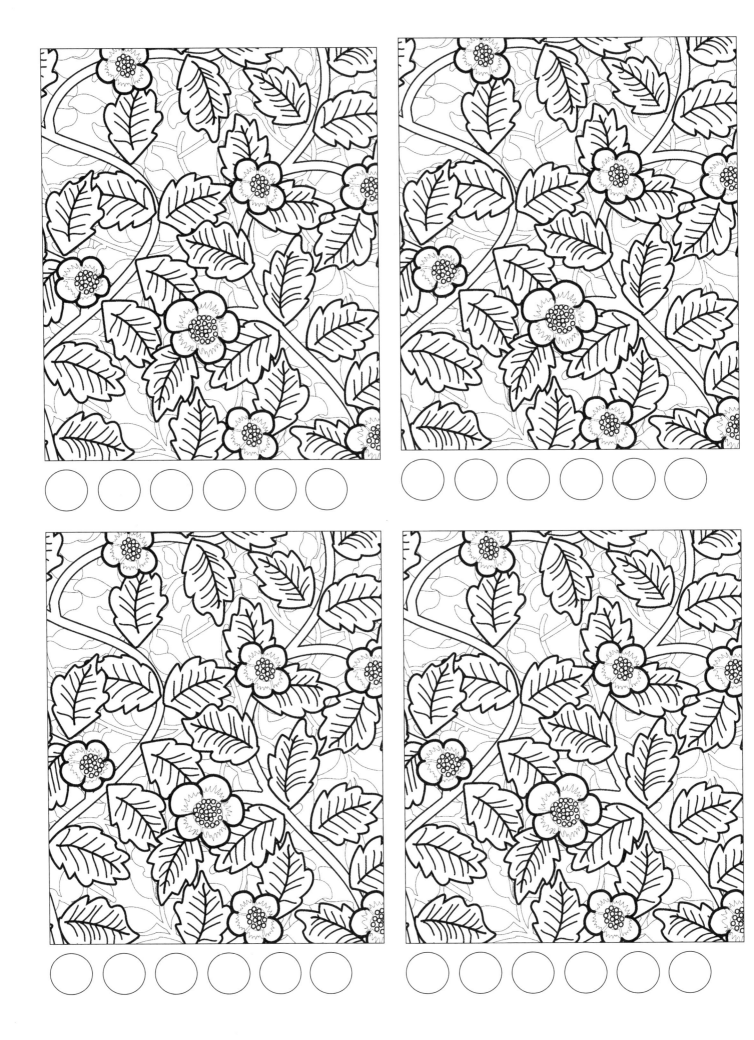

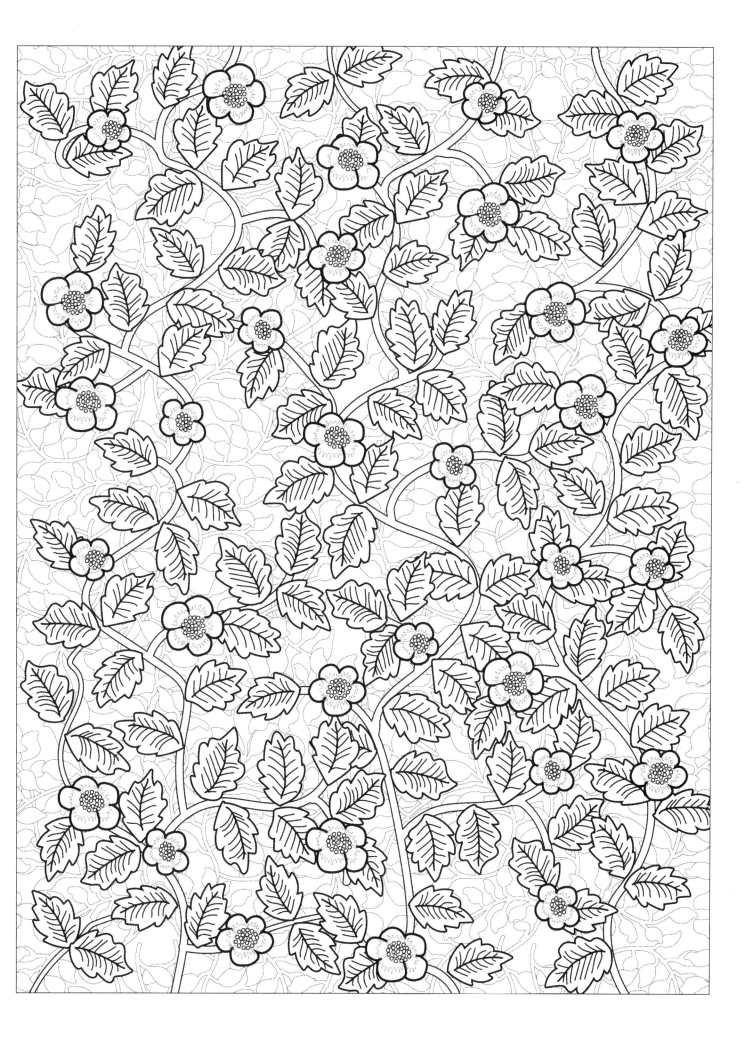

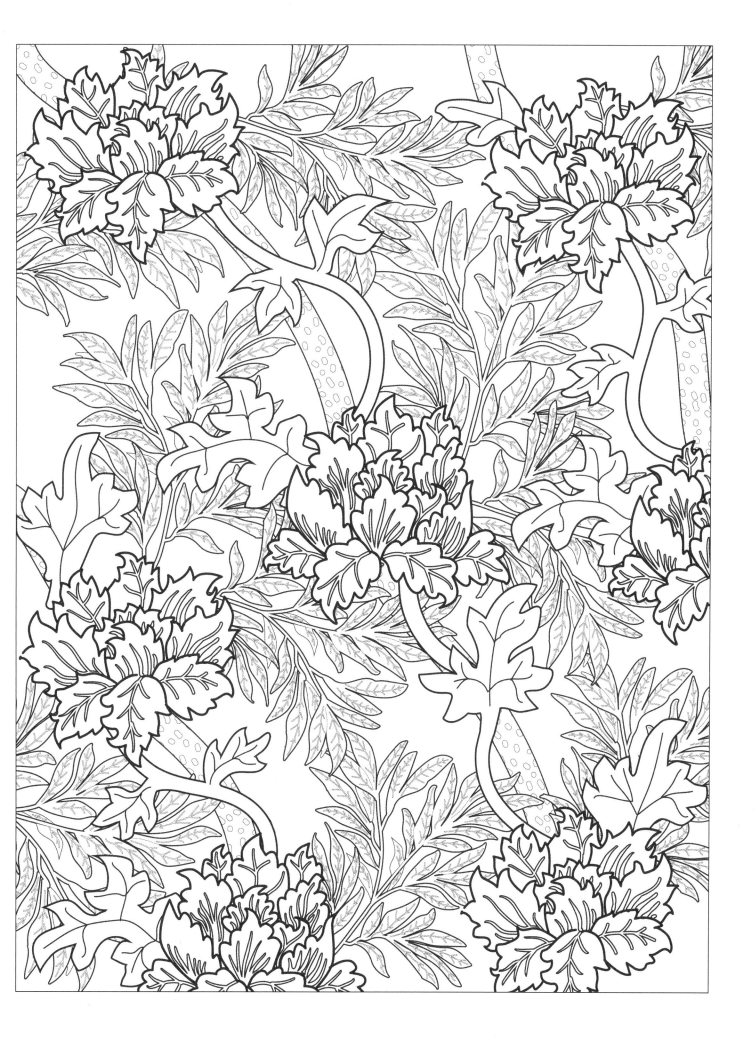

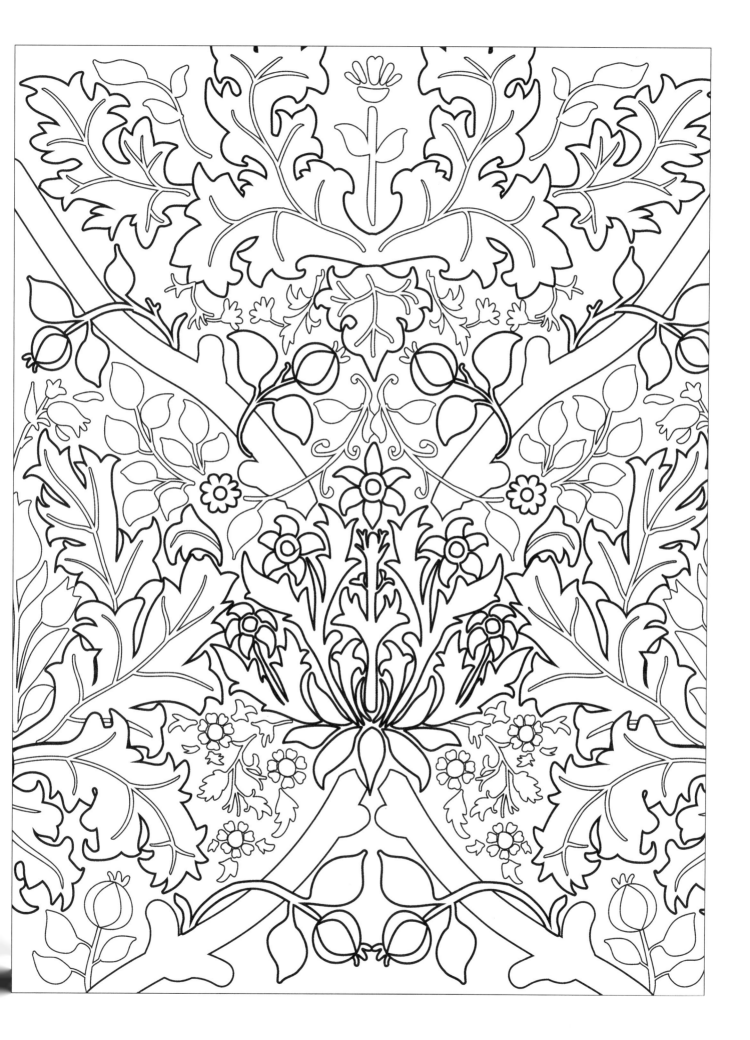

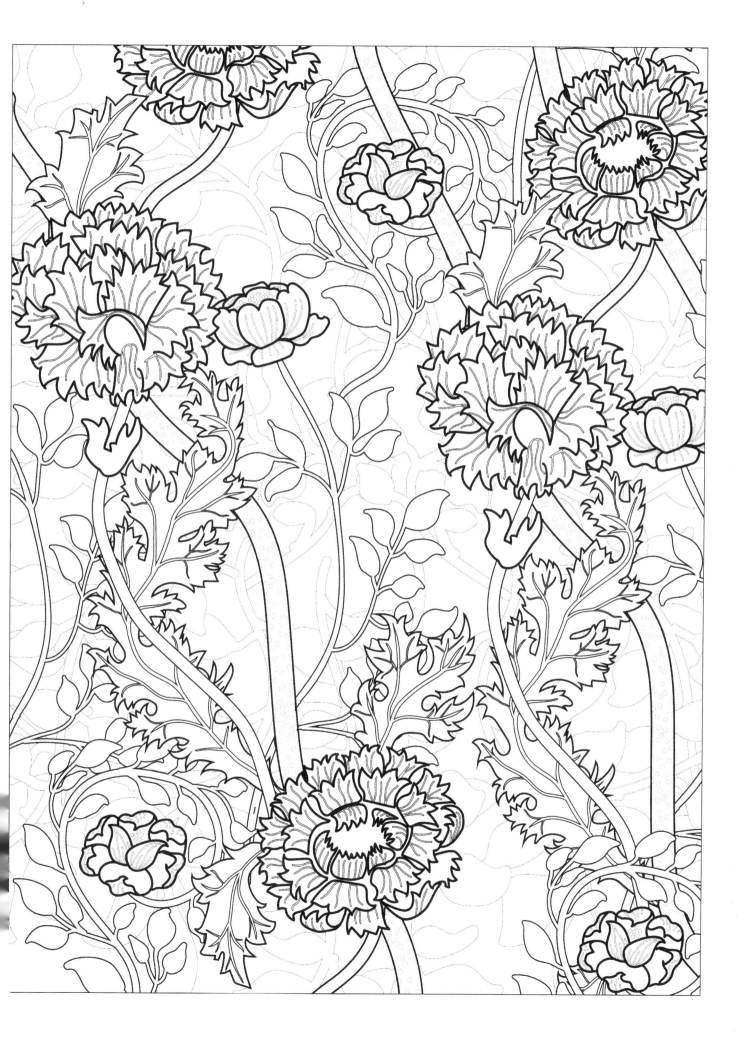

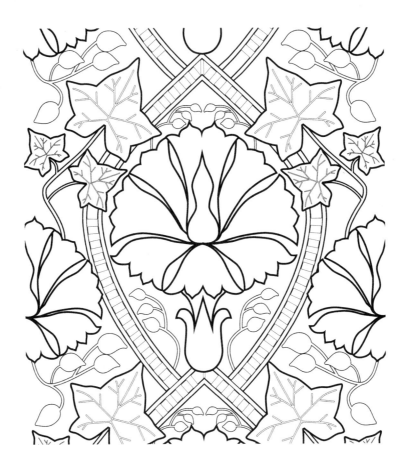

Get Creative 6

An Imprint of Mixed Media Resources
161 Avenue of the Americas, New York, NY 10013
© 2016 by Get Creative 6.

Illustrations by Petra Kokol.

Manufactured in China.
13579108642
First Edition.